DELAWARE BEER

THE STORY OF BREWING
IN THE FIRST STATE

TONY RUSSO

Foreword by Jim Lutz

AMERICAN PALATE

Published by American Palate
A Division of The History Press
Charleston, SC
www.historypress.net

Images courtesy of Kelly Russo unless otherwise noted.

First published 2016

Manufactured in the United States

ISBN 978.1.46711.910.8

Library of Congress Control Number: 2016930809

CONTENTS

FOREWORD

Being born in the "Beer Capital of the World"—Milwaukee, Wisconsin—and having my Uncle Jack working as a master brewer for Schlitz in the '50s and '60s, you might say that brewing was in my blood. I watched over the years as major breweries closed their doors in the Midwest due to many factors.

When the brewing industry began here in the States, the early brewers needed fresh water to make their lagers. The ability to filter the water at that time was not available, so fresh water was key to making a great lagers or ales. Most towns/cities around the country had their local beer and may have only sold it within one hundred miles from the source.

By the time I was old enough to work in the beer business, I went to work for the Pabst brewing company in its young adult marketing department while in college. I was able to see firsthand what was happening to a lot of these breweries. For many reasons, some of them did not change with the times and had to close their doors in and around the Milwaukee area—Pabst, Schlitz and Blatz, just to name a few. This same trend was happening around the country. Local breweries were being replaced by national brands that had figured out how to transport beer from the source in refrigerated railcars and trucks (keeping the beer cool and fresh) to local distributors around the country and then to retail shelves and on draft in bars. These breweries began advertising on national television using sports figures and the like to market their products to the younger (drinking age) generation. Soon the "race was on" to get that next group of beer drinkers.

Some of the local breweries did not make that change and kept flogging the consumer with the same old stuff. As time passed, these breweries lost market share and were forced to close their doors, and the Big Three got even bigger as these local breweries closed down.

Many years passed and the tide started to change. New brewer pioneers began making products for their local communities, and again "the race was on." I remember my first Craft Brewers Conference (CBC) in Milwaukee, Wisconsin, back in the early '90s. It felt like there were fewer than one hundred breweries there to share ideas on how to make, market and sell their products. These brewers shared ideas among themselves to better their products and increase sales and market share. How to get their products to market through distributor networks and then onto the retail shelves and pubs was the big challenge. This is something that was unheard of with the "Big Three" back in the day. Now when you go to the annual CBC conference, there are more than four thousand breweries there sharing ideas and working together to better the brewing industry.

Like with the early brewing pioneers, these new brewers have a passion for beer and flavor. They also have a passion for their local markets. Many of us only market/sell our beer in a small radius around our breweries, just like our forefathers were doing when they came over to settle here in the United State. Water is not an issue due to filtration, and transportation is not a problem either. Selling our products close to home allows us to connect with our consumer. We open our doors on weekends and allow people to come in to taste our products and see how we are making "their beer."

It has been a pleasure to know Tony for years; his passion for good beer and his ability to write about it has helped the growth of the craft beer industry.

–JIM LUTZ

Jim Lutz is the president/CEO of Fordham and Dominion Brewing Company. He began his career in 1979 with the Pabst Brewing Company in its young adult marketing department. He made the switch to craft beer in 1985 when he took over as president of Wild Goose in Cambridge, Maryland. His storied résumé also includes a stint at Flying Dog Brewery.

PREFACE

In speaking with Ronnie Price, who had just opened Blue Earl Brewing in Smyrna, I had a bit of a chance to talk about my job. Ronnie had been telling me about how seriously he takes his UnTappd scores. For those of you who don't know, UnTappd is an application that allows beer drinkers to transform themselves into impresarios by scoring beers on a scale of 1 to 5. Before the Internet, the real beer geeks who traveled abroad and to one of the six hundred or so breweries in the country at the time used a notebook to score the beers they tried. They would make detailed notes and had an objective understanding about the term "mouthfeel." They used those notes to make themselves better, more intentional beer drinkers, just as a wine aficionado might. I told Ronnie that I never scored a beer worse than a "3" because even though these notes are for me, they are public. Also, if we're going to be honest, I am kind of an idiot. I like being part of the culture and taking pictures of myself and my friends enjoying beer. Even though this is my second book on the subject, and I cohost a weekly beer show and produce blogs and articles for free and for pay on the subject every week, I'm not a beer writer in the regular sense of the word. I don't write reviews or cover breaking news. I don't brew my own beer, or anyone else's for that matter. I write about culture. From the time I was a student, I supposed that bars, taverns and breweries tell us more about our culture than almost everything else.

What has happened to craft beer since the end of the twentieth century certainly can. This book isn't meant to be a survey of what happened between the time the Dutch landed in Delaware and the time I stopped

typing because I was out of time and there were still breweries and brewpubs opening daily. Instead, it is my attempt to tie together the way that people *do* beer with the whys about its success and meaning. The whos pretty much take care of themselves. What is in the book will, with any luck, be revealed in the chapters that follow, so it's probably easier to tell you what isn't. I'll start with the work of two other authors: John Medkeff Jr., whom I'll mention again in the first chapter (for the dizzying number of people who read a book but skip the preface) and Sam Calagione.

In *Delaware Brewing*, John covered the history of Delaware beer in a way I couldn't. It is a fair and accurate history that wrings the colonial and industrial history out of sources in a way that I frankly don't here. At this writing, I haven't met John, but in going through the archives in Wilmington, I could see his fingerprints clearly still. I was unable to uncover anything he didn't (except maybe a letter ordering up a Swedish wife who could brew), so I operated under the assumption that people dying for those details are better served by him. If you page through the first chapter unsatisfied, his book has more details.

Sam has owned and run one of the most important craft breweries in the country since the end of the twentieth century. He has written a number of books on the subject that are entertaining and informative. I've included enough about Dogfish Head for context, much of which I got speaking to other brewers he has helped, as well as from Sam himself, and also my own experiences covering the brewery as a newspaper reporter and beer blogger (God, "beer blogger" is a humiliating title).

The fact is that Dogfish Head needs its own book, and that just isn't what I do. My interest and skill is talking about people who changed the world less obviously. There's plenty in here about Dogfish Head, but it isn't what might be referred to as "historically comprehensive." Instead, if I've succeeded, the story lays the groundwork for how Dogfish affected the other dozen breweries that followed it. What my father called "those oddball beers you drink" had, I argue, the effect of giving bankers and other investors permission to believe that oddball beers were worth investing in.

The reason I wrote this book, and the reason I do most of the writing I do, is because I like talking to people who are doing cool things and telling other people about them. I like tying things together in the present as well as to the past and guessing how they will affect the future. In what follows, we will meet people who don't know how they fit into the history of brewing and, particularly, into what might be the most exciting thing to happen to beer since a prehistoric tribe happened across a fermenting jar of barley.

ACKNOWLEDGEMENTS

My father, Charles Anthony Russo, isn't going to read this book, which is kind of tough. Although you don't know it, this book came out a few months late because he died during its production (but not because of its production—that would be really weird). He got to read the last book, though. He bought a bunch of them and handed them out like cigars, which felt nice. My family takes death with a sense of humor as best it can, so it was fun to have my aunts, uncles and cousins teasing me (and him in absentia) about who had to buy one and who got one as a gift. So whether you bought this book or received it as a gift, thank you for bothering to read it (especially the acknowledgements, as I know they can be painful).

It's important to thank my brother Bobby and my friend Keith Lodzinski, who have drank more craft beer with me than any two people who totally can't stand the taste of beer. They have suffered my excursions and even proposed a few. No matter what beer I bring them, they try it open-mindedly. My other brothers—Michael, Joseph, John and Daniel—like beer more and are always nice enough to make certain I don't have to drink all of it by myself.

Doug and Patti Griffith, who run Xtreme Brewing, the local homebrew shop where I lurk and learn without ever actually brewing, have provided a wealth of information to me. Doug, in particular, has forgotten more about brewing, Dogfish Head and the homebrew and craft beer revolution than could fit in three volumes. Any leaps I made about the history of brewing, or any facts that I couldn't cite because they were in my head, come from him. Unless they're about England—then Edd Draper gets the credit.

ACKNOWLEDGEMENTS

Nearly all of this book was written because the brewers and their families were kind enough to share their stories. I'm pretty sure everyone who spoke to me to let me know how they saw themselves and others as part of the craft beer culture gets a mention. It takes more courage than you might think to tell a stranger your story. Thank you for sharing. I hope you're happy with the result.

I got to talk to a lot of craft beer legends, but no one more important and unsung outside the craft beer trenches than the gentleman who was kind enough to write the foreword and give me a complete and honest history and assessment of the rise, fall and rise of the craft beer industry. Jim Lutz doesn't pull punches because he epitomizes the craft beer industry. He does what he wants to do because otherwise why bother? Thanks for your help and insight. Thanks also to Ryan Telle over at Fordham and Old Dominion for conducting us through the Dover culture and operations.

My boss, Ann McGinnis Hillyer, allowed me to split my time writing for ShoreCraftBeer.com and working on this book. She did it because she thought it was an important project and is crazy to a fault about craft beer culture. She probably won't get a plaque when this region becomes a beer destination, so this will have to do.

My friend Stephanie Fowler is an indie publisher who, as my deadline came and went, mocked rather than encouraged me, reminding me about how easy I said it was to finish a book. Boom.

My daughters—Amanda, Melissa, Megan and Allison—opened every phone call or walk into a room with, "Are you working?" No, I probably wasn't, but thanks for checking.

It is important to acknowledge my mother, Madeline (although that's not what I call her), for staying tough and staying on me. Not as I wrote the book, but as I learned to write and to read and to talk to people. The confidence I use but haven't earned I got from her.

It would be a crime not to acknowledge the woman who shot most of the photos for this book, Kelly Russo. She married me completely ignorant of the fact that she would eventually be engaged in artistic servitude. Most of you bought this book because it happened to be about beer and because it was so pretty. I think she's prettier, and she's better at her job than this author is at his.

Finally, and as always, thank you for reading and for supporting regional culture and craft beer. Drink what you like and be happy.

Introduction

Our fascination with brewing is probably older than our fascination with cooking, insofar as the two are different things. But although we have been drinking beer, many historians claim, for longer than we have been doing anything else except maybe walking upright, beer only has been interesting as beer in the mass consciousness since, at the outside, the last third of the twentieth century. It's remarkable when you think of it. To say we're living in a golden age of beer doesn't get at the half of it. We are witnessing the de-commodifying of a product that has spent the better part of human history as a commodity. When before has that happened?

Before the last few decades of the twentieth century, types and kinds of beer were differentiated exclusively by marketing, associating a particular beer with a particular lifestyle. Today, it isn't even surprising to see one beer touting another. At the 2015 Great American Beer Festival, John Panasiewicz, the head brewer at 3rd Wave brewery in Delmar, wore two T-shirts. The first was for Mispillion Brewing Company, a craft brewery in the same market. The second was his 3rd Wave gear. When it was announced that Wonka Bar, a chocolate stout made by Mispillion, had won the silver medal, John peeled off his shirt and accepted the award because he knew his friends couldn't make it. This is an industry that competes only in that people try to outdo themselves every time out.

There are lots of reasons why craft beer was able to be successful enough to explode in the twenty-first century. One of the most common observations is that the rise of the Internet meant that information became easier to come

by and marketing became less expensive. While that is true, it is true for all industries. Netflix, however, would be unlikely to accept an Emmy presented to Amazon if that company's representatives were too busy to make the show. There has to be something else going on.

What separates beer and brewing from almost every other industry, including wine and spirits, is that it always has been the result of a group effort. It is inexpensive enough that even the higher-end beers can be enjoyed regularly and complex enough to catch the imagination of gourmands and chefs alike. Craft beer also has had the fortune of wearing the David hat in its continued fight against the international conglomerates that still run and own the better part of the world's beer supply. They are not Amazon and Netflix, true, but they don't aspire to be.

In what follows, we'll take a look at the trends that were in place before Prohibition and how they changed afterward. Beer was always a necessity, until it was banned. After Prohibition, it became something of a luxury, but it took another sixty years for people to make it as if it were a luxury. The thing is, especially in America, beer wasn't taken seriously as an indulgence until just recently. Although there were always people who wanted to elevate beer throughout history, it took the rise of the homebrewer to release it from the constraints of pedestrian expectations. Once people figured out that there was such a thing as great beer, and that it could be made and sold for a living, it took off like a shot. The fact that it took so long to get there was the result of the industrial age. Mass production might be the longest-surviving fad in the history of humanity. For 150 years, most of us thought that it was better to make a lot of stuff that most people didn't hate than a little stuff that a few people liked a lot. What follows is the story of how beer illustrated that possibility and allowed it to spread into the larger artisan movement that is just underway today.

WHAT IS DELAWARE BEER?

As heartbreaking as it may be for some people to hear, beer doesn't have terroir, only attitude. So, talking about what makes a Delaware beer its own thing isn't going to be a question of nuances that a person has to be trained to detect; it is going to be a question of looking at the whys of beer within the whens. The same can be said to apply to American beers as well. For American beer, it always will be about attitude over the subtleties of flavor that sets the craft beer apart.

No craft beer lover ever has traveled abroad and not spoken about how dumbfounded they were to see Budweiser right alongside the best of the European beers in an English or Irish pub somewhere. Their confusion is the result of imagining that, given the opportunity for something of superior quality, taste and overall craftsmanship, no one would choose something inferior. Maybe that's more generally true of wines, but beer is its own animal. Beer has spent most of its existence outside of taste in the culinary sense but at the center of taste in the aesthetic sense. The riddle of Budweiser in the heart of British beer country is easily explained by remembering that American beer is all attitude and nearly zero terroir.

COWBOYS ARE EVERYWHERE

The attitude that is American beer is fully four hundred years in the making and really has only emerged in the end of the twentieth century. Before that, most American beer was a pale copy of European beer. From the time the first beers were brewed, they were done so in an attempt to re-create beers that had already been popular for decades elsewhere. American beer is less than one hundred years old, and its roots lie not in commerce or copy but rather the notion of American individualism that we have cultivated in both practice and mythology since we began looking west.

In Delaware, this notion of independence was as strong as anywhere else, but as a port state, the route toward independence was for a long time tied to financial well-being. Delaware has a long reputation as a business-friendly state, and the bigger the business, the friendlier the government. From the time it was a Dutch colony, Delaware had a "go big or go home" attitude toward beer, but by "big" it meant wide, which was an attitude that essentially kept it out of the American brewing game until the end of the twentieth century.

This isn't to say that there wasn't beer brewed in Delaware. It's just that, as with most other beers on the continent, it was particularly European. When Delaware beer did distinguish itself, it did so in a way that was anti-commercial, for the most part.

From the earliest successes with refrigeration in the late 1800s until Dogfish Head Brewings and Eats and Stewart's Brewing Company opened in 1995, Delaware beer was caught up in the industrial age and all its trappings. It was a fact that cost the state any for-profit brewing for nearly fifty years. What the new brewers came to understand, and what the new model of brewing became in the early twenty-first century, was that success is more about the relationship between you and yourself than you and your accountant.

The most troubling result that refrigeration brought us was the depersonalization of beer (and food more generally). But personalizing food as well as what we wash it down and flavor it with isn't merely back in vogue; it reveals every day the folly of industrialized pleasure.

Here we will take a look at the beer model in Delaware that led to the twentieth century in brief. It is fair and important to say that John Medkeff Jr., in his recent *Delaware Brewing*, has done a more-than-adequate job in detailing the colonial and industrial era of Delaware beer. We used many of the same sources, and in the end, it was decided that the same story didn't need to be told twice.

Gambrinus is a popular beer folklore character, often credited with having learned to brew beer from the gods. Although his historical origin is murky, statues of him can be seen adorning the fronts of breweries throughout history. In fact, a statue of him stood at the Diamond State Brewery even after the building was no longer a brewery. *Library of Congress.*

The bulk of this book will take a look at how many of the pieces that make up the current Delaware beer community, particularly the influence of the homebrew culture, have not only separated Delaware beer from European beer but also, to some extent, made it particular to the First State.

Amstel (Light)

Setting aside the regional airport, the strip malls and the looming Delaware Memorial Bridge, you almost can still see the rural nature of New Castle County if you know where to look. Along the inland rivers and bays that

stretch both from the Atlantic on the east and the Chesapeake Bay on the west, it is easy to see how the earliest settlers dreamed big when it came to all the possibilities the land held. It was fertile and, for all practical purposes, unsettled. The natives were amenable, so far as the earliest settlers could tell, to selling off land rights, leaving ample opportunity for a massive agricultural and fur trade to be developed. From the first, Delaware was all about the resources.

What set it apart in the mid-seventeenth century was that it was not an English colony, but a Dutch/Swedish one. The two northern European nations were working at cross purposes to establish a foothold in the New World. Amstel (modern New Castle) was a Dutch property, and Fort Christina (near modern day Wilmington) belonged tenuously to the Swedes. Peter Minuit, of Manhattan Island–purchasing fame, orchestrated the establishments of each of the earliest settlements while under contract first to the Dutch and then to the Swedes.

From the earliest days, the Dutch saw the beer possibilities in the vast, open land and the modest climes. Barley grew well and easily, and although it never was a completed project, the settlers had designs on exporting beer

This sketch of a Wilmington barley mill dating back to the 1890s shows a much more pastoral Wilmington than we tend to think of. Barley grew well even in the earliest Delaware settlements. *Library of Congress.*

back home, as well as to their neighbors in Maryland. But even though the exporting project never got off the ground, there was plenty of day-to-day brewing going on. Professional brewers tended to be men, but household beer was made by women as part of their daily chores. In fact, Johan Classon Risingh, who was the final governor of New Sweden before it was lost to the English, wrote home for a wife and specified "that she should be able to look after the garden and the cattle, to spin and to weave both the linen and the wool, to keep the nets and the seines in order, to make malt, to brew the ale, to cook the food, to milk the cows to make the cheese and butter." Long walks on the beach were optional.

Although the Dutch, like the Germans, had a tradition for lagers and pilsners, they also made brown ales and stouts. In the twenty or so years they occupied the area, it likely is the case that they made the preferred lagers over the long winters in Delaware but also had a complement of ales to get them through the harvest and back into the cooler weather during which they could brew their lagers. Lagers ferment at a lower temperature than ales, and in the pre-refrigeration era, they were stored up over the fall and winter for drinking throughout the spring and summer. The choice between a lager and an ale today is seen as something of a preference, but that only became true with the rise of refrigeration.

Before the seventeenth century was over, the Swedes and the Dutch would lose control over Delaware. New Amstel was renamed New Castle (its English equivalent), and the English began governing the colony as their own. In those intervening years, however, Delaware was something of its own melting pot. Swedes, Dutch, Belgians and Germans all carved out places for themselves and, much as in New Amsterdam before and after it became New York, wove themselves into the culture in a permanent way. As a result, the beer would have remained diverse for much longer than in places where these groups existed to a greater extent and were more easily marginalized.

CITY BEER AND COUNTRY BEER

The sheer number of beers from which we can choose today is mind-boggling from the perspective of brands. There are hardly any craft brewers who make fewer than two kinds of IPA, but that doesn't mean there are more kinds of beers—only a greater number from which to choose. The perception that a wide diversity of beer is something novel is a function of the industrial

age, where we as a culture have done a better job of organizing things into groups, whether that be beer, apples or artisanal lip balm. Beer is having a reverse renaissance, and styles that used to be made are being rediscovered. It is critical to remember that people "homebrewed" for millennia before the invention of production breweries. In fact, for most of the seventeenth and eighteenth centuries, taverns were owned by people who were making beers out of whatever they could lay their hands on. There was also something of a creative factor. City taverns have been trying to distinguish themselves using fare, drink and even entertainment diversity ever since the invention of cities.

For most of industrial history, however, the only distinction in beer has been production demands. In cities as late as the late 1800s, many pubs were making tavern-specific beer. Some of that beer was to stay, and some of it left in pails or bottles or occasionally kegs. There were people who made beer for a living, and that living depended on appealing to the greatest number of beer drinkers. In the country, however, it was a different story.

Sussex County, which makes up the bulk of the state's land mass, is decidedly rural today. In a world where there were large farms in Wilmington and New Castle, the lands of Sussex County were practically primeval. Certainly there were city centers, like Georgetown and Lewes, and those centers had one or two taverns. But the best kind of beer brewed in Delaware was the kind that appealed to the brewer, who likely was the farmer's wife.

Provincial Delaware was a place where beer was almost unrecognizable by modern standards. In fact, it more resembled cider than beer, although both were made and distinctive. The greatest difference between beer and cider is the amount of sugar and presence of malted barley. Malting barley is akin in skill level to roasting coffee. It is something that anyone can do at home but that takes artistry to do well. By the early to mid-1800s, malt was available at general stores and could be purchased like flour. Before that, malt was expensive and rare, so country beer was primitive.

Simply put, beer is made by boiling the sugar out of malted barley, adding yeast and waiting. Today, there are thousands of yeast possibilities, but for much of history, luck was the prime way people got yeast into beer. Another reason why beer doesn't have terroir is because to make good beer, you need good, predictable yeast. Unlike wines, which even before beer had predictable yeasts that grew right on the fruit (the white residue you sometimes see on grapes is yeast), the beer yeasts used in colonial homes were not always predictable.

In colonial times, and really into the early 1800s, yeast wasn't so much a cultivation as it was an occurrence. Once the beer cooled to about sixty degrees, yeast would be attracted to it and begin to produce alcohol and more yeast, which could be harvested and propagated depending on the brewer's disposition. After a week or two, the yeast would be spent, having eaten all the sugar. The beer was then bottled, casked or, in homes with less means, drunk from the vat.

Some evidence suggests that in poorer homes, where malt was not used, molasses provided the fermentable sugars. Housewives would boil barley together with molasses and, after removing the boiled barley, ferment the resulting liquid with whatever yeast landed on it. Often fruits, like pumpkins, peaches or cherries, would be added to the cooling brew for the yeast that naturally was attracted to them. It probably wasn't the kind of beer you would bring to a pairing or brag about, but it had the advantage of being produced quickly from storable goods.

In American cities (for our purposes in Wilmington and New Castle), there were maltsters and brewers right off, people who were in the beer trade. But country beer was wholly different in process as well as in function. It was an even more specific and individual production.

IN A WORLD WITHOUT ASPIRIN

It is a little-known fact that apart from alcohol poisoning, beer can't kill you. The fermentation process kills all dangerous bacteria. For a while, it was rumored that colonists drank beer and cider exclusively because they feared waterborne illnesses. While this certainly has a bit of truth to it, the fact is that by the mid-1700s, water was referred to as a staple beverage, meaning that the issue was overcome with wells and time.

But just because the water couldn't kill a person didn't mean it was all the better for drinking, particularly in the country. City water always would be questionable, which is why city beer always was more popular. Drinking on the farm, however, was a bit more complicated.

In both the pre- and post-slave economy, life on the farm was, by our terms, oppressively hard. Days were long and filled with callus-provoking sawing, hoeing and digging. Every log you used to heat your home was cut by your own hand, as was the house within which you lived. While there were a number of plantations, southern Delaware was dotted with

Left: Germans weren't the only ones welcome at the American beer gardens of the nineteenth century. Even as the immigration numbers surged, the brewers did a lot to encourage people to enjoy German beer. *Library of Congress.*

Below: Before Prohibition completely ended, a low-alcohol beer was available, and working men took advantage of it. Here, a group of Civilian Conservation Corps workers in Wyoming, Delaware, take a break with their favorite beverage. *Delaware Public Archives.*

small family farms where sustenance farming often was the order of the day.

In moderation, alcohol (and particularly beer and cider) kept the aching down and the spirits up. It wasn't any easier to run a farm besotted then than

it is now, but a steady diet of low-alcohol beer or cider could take the edge off a hard day's work, and often it did.

For many of the southern plantation states that relied on slave labor heavily, rum punch was the primary field drink, supplemented with water. Delaware traded in slaves but relied on them much less than did its southern counterparts. First, its economy rested pretty heavily on its ports, so while there was money to be made from the slave trade, it wasn't so much extracted from labor as from potential labor. Second, beyond food crops, Delaware grew primarily wheat and barley rather than tobacco and cotton, and these didn't require the same intensity of slave labor as did the states that relied on those exports.

This kept beer (and, to some extent, cider), which was a little more labor-intensive for the farmers' wives, as a fairly common field drink. In a world with no hops (or, really, not much access to hops), the beers were bittered by roots and other spices that might take the edge off the molasses's sweetness. Remember, they were drinking something that likely tasted like alcohol-infused porridge—playing with flavors came naturally to early American homebrewers.

Pumpkins, sweet potatoes and gourds flavored fall and winter beers, just as natural herbs like cassina flavored beers through the winter and into the spring. These had the dual effect of softening the flavor of the mash (barley mixture) and hiding what now would be referred to as "off" flavors produced from using wild yeast. Wild yeast particularly is known for producing the sour flavor that has been popular among beer makers for centuries. From summer on, though, there probably wasn't a lot of awful beer being drunk, as there were better ingredients available.

SOMETHING MORE PRACTICAL AND EVEN MORE TASTY

If the ability to store barley and molasses made beer the most reliable beverage, cider certainly was the more popular of the colonial provincial drinks. This had to do with the four main ingredients in beer: water, barley, hops and yeast. The barley had to be augmented with molasses to ferment, and hops were unreliable in Delaware's humid climes, susceptible as they are to disease. Once the apples, peaches, strawberries and other fruits began to bloom in the midsummer, it was cider making and drinking time for many. This could have been from habit as much as from practicality. In parts of

Bavaria, it was illegal to brew beer during the summer, as fires spread easily during the summer dry season there.

Today's brewers and homebrewers can start a boil, set a timer and do something else while the water heats and the mash boils. For much of history, though, the boil occurred over an open fire. People couldn't be bothered hanging about just to make sure the fire didn't leave the ring and spread to the nearby buildings and fields. In a world where hunting and agriculture took up the better part of a person's day, whether to leave the fire unattended was a real problem. Even in places where it wasn't banned, it would have been a chore to stay near the fire; other methods also rose to popularity.

Unlike beer, cider doesn't require boiling because it doesn't rely on heated water. Cider literally is the juice from a fruit and sugar added together and fermented. The sugar increases the alcohol content and makes for a hardier beverage. The wild yeast combined with that occurring naturally on the fruits, but any sour or "off" flavors would have been buried in the interplay between the natural and added sugars of the fruit in question. On local farms as well as in the towns, cider was prevalent as long as the harvest and the weather held. The difficulty, such as it was, was in affording the sugar for cider, which was more expansive than the molasses for beer.

Molasses is a byproduct of the sugar refining process. In the seventeenth and eighteenth centuries, more molasses than sugar was produced from each cane, but even as the process got better, molasses remained an incredibly valuable import in the colonial and early American era. Certainly with the New England distilleries producing much of the world's rum, a lot of the molasses was imported for that reason (rum is fermented, distilled molasses). The quantities that were imported into Delaware, however, show that the cheap molasses was useful as a sweetener and a supplement for livestock food. Add to that that molasses likely was the sugar that helped turn unmalted barley into beer and the sticky sweetener had a multifaceted value.

But if molasses was cheaper, it wasn't better in cider and would have made something very palatable much less so. It makes more sense to suppose that even among those who didn't have or couldn't afford sugar for fermenting cider were likely to use the naturally occurring sugars in the juices to produce the alcohol. Given that Delaware had balmy summer temperatures, it isn't unreasonable to believe that fermentation was easier then than now both because of the stable summers and the concentration of yeasts.

There also is something cultural to be said for beer, even if it wasn't the best-tasting beer anyone ever had. First, it was easier to store and less likely to spoil than cider. Moreover, it was cheaper to make. Thomas Jefferson's beer

used bran, which was essentially just a byproduct of the milling process, and persimmons. Bran provided the barley flavor—the thickness that underlies the sweetness of the malt even today. The persimmons, an astringent fruit, acted as a bittering agent. Today, we think of beer as something we can have or do without, but it was a staple of civilization for most of the time people have been walking upright. Beer is something we find a way to make. As long as we are going to bother making it, we might as well try to make it good.

HERE COME THE GERMANS

It is hard to overstate the German influence on America in the nineteenth century. By 1815, America had firmly established its sovereignty and already was beginning to deal with the implications of slavery and religious freedom. Although Germans had made up a significant part of even the New Amstel colony, they didn't begin seeing the United States as a viable emigration option until then. Once it became clear that there was fertile land to be had, plenty of work and a culture of religious tolerance, Germans began making their way across the Atlantic in numbers that wouldn't be repeated for a century. Since many of the places the new immigrants settled were not unlike the regions from whence they had come, their customs traveled and assimilated pretty easily.

The wave began in the 1820s, with farmers and land speculators gobbling up chunks of Pennsylvania and leapfrogging west with the rest of the country as part of the great westward expansion. Germany underwent its own revolution in 1848–49, and by the 1850s, millions more had begun arriving. Mostly this served to populate the Midwest. The beer barons began arriving just around this time, with Eberhard Anheuser arriving in 1842, Bernhard Stroh in 1849, Joseph Schlitz in 1850, Frederick Miller in 1854, Adolphus Busch in 1857 and Adolph Kohrs in 1868.

The Germans, who literally moved mountains to make the lager they loved, are an excellent example of beer's cultural power.

GOOD BEER IN STORE

In German, *lager* means to store. Lager beers are brewed to be stored at a constant, cool temperature to allow the yeast to ferment the brew properly.

For centuries, this meant using caves to store (or lager) the beer. This wasn't too difficult a problem in Pennsylvania and the Midwest, where many of the German population centers were. Caves were easy to find or dig or both, allowing the beer makers plenty of volume to meet the ever-increasing demand placed on production by the rising tide of immigrants, as well as German beer converts. Delaware wasn't so lucky.

Like many of the East Coast cities, most of the land was taken up by buildings long before there was a chance to do much digging. Southern Delaware had the particular difficulty of being nearly half marsh, making it great for farming and making ales but not for brewing the lagers more preferable to the Germans. In Wilmington, however, brewers were able to lager, if only a little.

Samuel Nebeker, along with his brothers, Aquilla and George, bought an abandoned quarry in town and used it to lager their beer. They, along with several of those who followed them, had difficulty competing in volume with the imports from Pennsylvania. Ships and railroads brought beer packed in ice that was made in the massive lagering vaults to the north and west.

The Nebeker brewery gave way to the A. Bickta and Company brewery when it was bought by a concern of local businessmen led by Augustus Bickta that included Joseph Stoeckle.

Stoeckle had been brewing for nearly twenty years by the time he invested in A. Bickta and Company, so when that company folded, he decided to make a go of it and formed Diamond State Brewing in cooperation with one of the other primaries, Frank Bickta.

By the time Stoeckle gained sole control over the company in 1874, the world had changed dramatically, especially for brewers. Out in St. Louis, Adolphus Busch had started pasteurizing beer and shipping it out in refrigerated cars. As the refrigeration technology improved, he was able to control a beer's temperature outside the lagering caves and do it directly in the tanks. This innovation, more than any other except possibly sheer market demand, allowed German-style lagers to replace the English (and German) ales that had been prevalent at the time.

Diamond State Brewery burned down in late 1881. When Stoeckle rebuilt it and reopened in late 1882, it was a state-of-the-art facility able to brew exponentially more beer each year, increasing from about four thousand barrels annually at the time of the fire to thirty thousand at the time of Stoeckle's death. German-style lagers would dominate American culture for the next one hundred years.

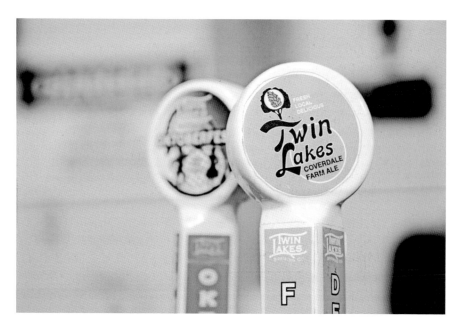

Twin Lakes Brewery in Greenville specialized for a while in pale ale, becoming the first brewery in the state to can and distribute its beers on a large scale. In 2015, it moved to Newton to begin a planned expansion.

Even today, beer is often stored in small barrels for specialty brews that have specialty flavors. Often the craft beers are aged in old whiskey or wine barrels to help them exhibit some of those flavors.

BIERGARTEN BLUES

Joseph Stoeckle didn't just buy his way into the beer business. Instead, he worked his way up, having owned and run a hotel and tavern before undertaking the larger venture that became Diamond State. His transition followed the general transformation from the brewpub to the megabrewery that would define America for the better part of the next century. More than that, with the coming of refrigeration began a battle for dominance between the larger beer companies that eventually would lend credence to the argument for prohibition.

Until the end of the nineteenth century, taverns were as likely to make their own beers as not. Stoeckle started brewing with his brother-in-law before eventually incorporating his saloon and hotel into a viable business. As the twentieth century approached, however, there was a distinct "go big or go home" approach to beer making that had been missing before. The industrial age had come to brewing, and production and efficiency became the order of the day.

In Wilmington, Diamond State beer was so successful that Stoeckle was able to open and maintain a beer garden on two lots that took up most of the 200 block on North King Street. After Prohibition, it would take something on the order of eighty years to get back to the beer garden mentality that surrounded brewing. While it wouldn't be completely accurate to say that beer gardens were not about drinking at all, they were by no means the frat parties they have sometimes been painted as.

In fact, not too much more than a block away from the beer garden, a group of immigrants had established the historic German Hall on East Sixth Street in 1853, more than five years before Diamond State even opened its doors. The hall was founded by a Saengerbund (choral society) but acted as a kind of welcome center for the scores of immigrants who were arriving in Wilmington. It was opened as a kind of traditional beer hall, where people would meet to host traditional festivals. The building was occupied by the group even throughout Prohibition but was sold in 1965 and relocated to nearby Ogletown, in Newark, Delaware.

Like the German Hall, beer gardens were family-friendly places. People would spend the day (and that day was often Sunday) with their families eating, drinking and maybe playing cards or just catching up while their children played in the open areas. Immigration is always a difficult transition. People come to a new place with new cultural expectations and need a little guidance about how to, if not completely assimilate, at least carve out a

place where they can thrive and maybe even prosper. Immigrant social clubs and, in this case, beer gardens helped support these transitions.

Aside from the camaraderie, social support and information, the beer gardens were a place of cultural familiarity. There would be musicians and other entertainers. The lagers of the day were made for drinking all day. They were low-alcohol beers, so a person could drink his or her fill without getting hammered. What became difficult for these German cultural centers were the spreading hostilities in Europe. After the turn of the century, as World War I loomed, a deep distrust of outsiders became another of the difficulties brewers faced.

The German Hall in Wilmington was built in 1853 to accommodate the waves of German immigrants making their way to America both to seek opportunities and to escape the civil war that was underway. *Library of Congress.*

The End of American Ales

There wasn't one reason why Prohibition caught on in America. There were dozens, but it started with the saloons and the race for market dominance. This began with brewers helping to open saloons in what is best described as an early example of franchising. Brewers would supply everything from the beer to the bar stools and spittoons in exchange for exclusivity. Beer was getting cheaper and cheaper to make and ship. The influx of immigrants from Europe, which started during the Panic of 1873 and ensuing worldwide financial crisis, drove down labor costs and allowed the United States to right itself prior to the turn of the century, while Europe's troubles really continued until the end of the Second World War.

Mass production still is an important part of craft brewing today. Shipping out smaller kegs, like the sixtels pictured, allows smaller breweries to have wider distribution but still maintain small-batch quality control.

There was a manufacturing boom and an explosion of urban populations that made it almost unprofitable *not* to be in the saloon business. The difficulty was that it became not completely unlike today's rush to build pharmacies. If a block had a Budweiser saloon, for example, it would have a Miller and a Schlitz in short order. Tavern owners had to move the beer, but they also began serving spirits, which had a higher profit margin. The working-class image of the tavern had devolved into the darkly regarded, seedy saloon by the beginning of the twentieth century.

Over the course of a few decades, the tenor of this competition also began to affect American society in ways that would change the country's relationship with all alcoholic beverages irrecoverably. It started with a rise in alcoholism. Spirits were so much more profitable that they were sold at much lower margins than beer. The working poor and the members of the emerging lower middle class took to alcohol for financial reasons as well as for recreational ones. Almost simultaneously, the middle and upper classes embraced the rise of the cocktail. The result was an increasing dependency on alcohol as a social lubricant in a way that was fundamentally different than before the wide availability of spirits.

Added to the rise in alcohol was the increasing fear of immigrants, and particularly of German immigrants. The civil war that had driven Germans

to American shores had resulted in a unified Germany that, under Keiser Wilhelm II, had renewed its drive toward imperialism. Broadly speaking, these two events, the rise of saloons and spirits and American xenophobia, combined to help turn the nascent temperance movement into a prohibition movement.

Temperance endorsed just that: less drinking and better controls. It succeeded at first, limiting (for example) the sale of beer on Sunday and establishing opening and closing hours for the saloons. The more zealous among their number helped lobby for bans and succeeded in some places.

The first casualty in the run-up to Prohibition was the English-style ale, which wasn't as profitable to make as the cheaper-to-mass-produce lagers. Moreover, as beer began to try and position itself as the low-alcohol alternative to spirits, lagers came more into fashion. By the time Prohibition was enacted and then repealed, the only beers that came back in a big way were the lagers.

Slowly at First, Then All at Once

Prohibition was primarily the result of a brand-new political invention: the wedge issue. Wedge issues are up-or-down, make-or-break issues. If a politician was not for Prohibition, there was no other issue that mattered to some voters. Longtime professional politicians started losing their jobs. There were appeasement tactics and laws put into place to try and reduce drinking rather than ban it.

Among them were bids to break up the distribution chain and give taverns a freer hand in what they sold. Breweries no longer could sell directly to taverns in some states; in others, there was a limit on the amount of annual production that could be undertaken. The laws varied from state to state, county to county and municipality to municipality. Eventually, though, nothing could stem the tide of politicians who feared for their jobs. The only barrier to enacting the Volstead Act was a revenue shortfall.

It was a different time, with different national priorities, but before Prohibition, alcohol tax accounted for 25 percent of the federal income. But that amount began shrinking annually with the adoption of the Sixteenth Amendment to the Constitution, which established the income tax in 1913. Three years later, the exemption on income gained from real estate was removed. Three years after that, the income tax revenue had completely replaced the alcohol tax. The following year, Prohibition passed. Federal

Delaware had a very active anti-prohibitionist movement. Being a women-led organization was important, since the prohibitionists had claimed that alcohol was destroying families. Women of good repute all over Delaware stood against Prohibition because it eroded respect for the law. *Delaware Public Archives.*

income tax was $20 billion in 1920. As the economy grew and there was near-full employment, the alcohol tax wasn't missed until the economy collapsed in 1929. After that, alcohol was missed in a big way.

GIRL POWER

Not long after the crash, it was clear to many that Prohibition had been a financial and social disaster. It eroded respect for the rule of law, and with unemployment hovering around the 20 percent mark (it hit a high of 25 percent), the income tax was an insufficient replacement for the tax at best.

One of the difficulties was that the case for Prohibition had been made, in part, by an appeal to the welfare of women and children. Less than a decade after claiming that it was for their protection that alcohol be banned, repealing it was a tough sell. Enter the Women's Organization for National Prohibition Reform.

The organization had been founded by Pauline Sabin, a Chicago socialite with New York roots. She led a coalition of unelected Republicans and Democrats who had been against Prohibition on financial, social and self-

determination grounds. Sabin had been present and vaguely offended when Annie Wittenmyer, the leader of the Woman's Christian Temperance Union, claimed to "represent the women of America."

Sabin's triumph was in turning the WCTU's arguments against it. She spoke on the prevalence of children gaining access to speakeasies and railed against the hypocrisy of a law where formerly law-abiding parents were happy to openly imbibe in their homes.

Sabin counted Alice du Pont, wife of the Wilmington industrialist Pierre Samuel du Pont, among her allies. Du Pont was a Women's Organization for National Prohibition Reform board member, along with other wives of the Washington and industrial elite. Women had gained the right to vote

Prominent society women who led women's wet organizations. The social register was well represented in the slats of officers for the Women's Organization for National Prohibition Reform. *Left to right*: Mrs. William C. Potter, New York, national treasurer; Mrs. Archibald B. Roosevelt, New York, national secretary; Mrs. Edward S. Moore, New York, member of executive committee; Miss Maude Wetmore, Rhode Island, national vice-chairman; Mrs. Charles H. Sabin, New York, national chairman; Mrs. William B. Mason, Washington, D.C., national vice-chairman; Mrs. Pierre S. Dupont, Delaware, national vice-chairman; Mrs. E. Roland Harriman, national finance chairman. Harris and Ewing, photographers. *Courtesy of the Library of Congress archives.*

in the political frenzy that gave Prohibition its earliest staunch allies. Once Franklin Roosevelt took the White House in 1932, he found that even his greatest detractors, including Du Pont and Sabin, could come together over the tax income boon that was repealing Prohibition. Suffrage was built on the strength of literate and sophisticated women, and they saw pretty quickly that they could continue to wield political power to improve their lot.

Back in Wilmington, Diamond State limped along, making near beer and hoping for the best.

Diamond State Denouement

With the eventual repeal of Prohibition, Diamond State made a legitimate go of it, but Prohibition had damaged American palates nearly beyond repair. A significant part of the early temperance movement was against booze but not beer. In fact, right through the enactment of Prohibition, there was a general surprise that beer and wine were included in the law ostensibly enacted to break the stranglehold that "demon rum" had on the lower classes.

Unfortunately for beer lovers, Prohibition had the opposite effect. Just as the pre-Prohibition saloonkeepers had sought profit refuge in spirits, so, too, did the bootleggers. Stills were easier to make and spirits easier to smuggle than beer. Making beer in any quantity at all required space and resources. Moreover, nothing made the front page faster than police breaking up massive barrels of beer confiscated in city raids.

A brewery could be hidden, for a while, in a city. In the country, however, it was impossible. Especially compared to a pot still, which could be more easily hidden and provided a much higher return on investment. This was particularly true in Delaware, where Sussex County was primarily swampland and smuggler's coves. The result was that during Prohibition, people who normally were beer drinkers got a taste for spirits and, particularly, cocktails. The cocktail boom of the 1940s and '50s came directly from the speakeasy culture of the Prohibition era. Meanwhile, the beer industry had something of a time reestablishing itself, and this resulted in consolidations and closings of many of the great breweries that existed in the early twentieth century.

The Stoeckle family leased out its brewery building to Adolph G. Dangel, who hired Harry Wachtel to run it. Diamond State Beer was produced just through the middle of the twentieth century, but the world had changed. In addition to the popular move toward cocktails, there was something of

a false paradigm shift that took place in the beer world not long after the beginning of the 1950s that would hold most American brewers under its sway for decades. For better or worse, let's call it the "Budweiser model."

The Budweiser model, which was subscribed to by all the major beer manufacturers, was distinctly a product of the Industrial Revolution. Beer always had been a commodity. It was sold in bulk and on the premise that it was wet and all tasted pretty much the same. Just as with the car model, people (and by people we mean men, and primarily white, working-class men) were enticed by lifestyle. Major brewers operated under this premise: given that all beer tastes essentially the same, consumers should be enticed to embrace the lifestyle associated with a particular brand.

Prior to refrigeration, people drank the beer nearest to them. Romantically speaking, they drank the beer that was provided by the same guy who polished the glasses and had his name above the door. In a world where very few people distributed beer nationwide, brand loyalty made zero sense.

But this was a new world. A world where a rising middle class defined itself by brands and brand loyalty. A world where if your dad drank Miller and drove a Chevy, so did you. It is particularly American. We were, as a country, in between immigrant booms, and each group was trying harder than the last to embrace its Americanness. The phrase "melting pot" had been coined in the beginning of the century, but in the cities there still were sections defined by nationalities and, in the country, towns and counties thus defined. Voting and the fact that we all had similar daily needs were the only things that bound us. Brands became a kind of clan because they had to be.

It would be vaguely inaccurate to say that it stayed that way in Delaware for the forty years between when Diamond State Brewing closed and Dogfish Head and Stewart's Brewing opened in 1995. The constant throughout, and the constant that Americans have as a culture, is the balance between the will to be part of a clan and the drive to assert our individuality. The better part of the twentieth century was dominated by brewers who wanted to sell a lot of beer, but the legacy of American brewing is the story of people who want to do what they want to do and do it.

In with the Old

The New Old Way

The craft beer industry is a new phenomenon. When you think about it, so is craft beer. There always have been small niche breweries and breweries that specialized in English-style ales. Lots of breweries survived the Depression, Prohibition and the various bouts of consolidation aimed at making the brewing industry more efficient. They all operated under the Budweiser paradigm, which said that beer was a thing to be mass-produced. Of course, mass production was more than a nineteenth-century fad, and beer wasn't alone in the mass-production craze. It is fair and important to point out that it was on the wave of mass production that the American economy endured and grew to the world's largest by the second half of the twentieth century. Whether mass production was still the most efficient way to make beer wouldn't really be called into question on a mass scale until the 1980s. Even major players in the early craft beer movement like Pete's Wicked and Samuel Adams approached the market from that perspective, espousing the notion that they could make good beer for mass distribution as long as people could be educated. The goal was to make better beer to sell at a premium to people who knew the difference. It worked, to some extent.

Small companies were able to have a small revival and carve out another niche for what was coming to be known as craft beer. The idea was to make small batches with good ingredients, to be precise. The goal appeared to be to change the system from the inside—to establish

Dogfish Head Brewings and Eats in Rehoboth Beach. This was the original site of what would become the smallest production brewery in the country in 1996. Sam Calagione started out making beers for his customers and those he could get to try it around the region. Eventually, the full-size production brewery would be established in Milton, and by 2015, Dogfish Head had become the thirteenth-largest craft brewer in the country.

that beer could be more than something that came from a can you then crushed on your head. Beer could be like wine, to some extent, but it could be complex without being stuffy.

There were a lot of difficulties elsewhere that didn't affect Delaware. Dogfish Head and Stewart's Brewing Company survived the tail end of the craft beer boom and bust that occurred in the late 1990s, such as it was, but they survived it by not being a part of it. Instead, they were among the earliest brewers that would grow to the size that made them comfortable almost incidentally. Those earliest breweries were part of the move to a homebrew aesthetic that would come to define craft beer.

All craft beer starts with homebrewing. Jim Koch of the Boston Beer Company first tested out the recipe in his kitchen. Similarly, Pete Slosberg of Pete's Wicked was a homebrewer who eventually became good enough to produce large quantities of great beer. The craft beer boom and bust was about expansion under the Budweiser model, which wasn't completely compatible with the craft process insofar as it included efficiencies and consolidations that cut out the viability for profitability in many of the

beer companies that formed, rose and fell between the early 1980s and the late 1990s.

Being a craft beer doesn't mean you can't be successful or grow, but starting a corporation for producing large amounts of great beer consistently wasn't something that really had been done before. The market had to be established and created, and it had to be done (or so it was thought) along the lifestyle model. There had to be an appeal to associating the beer with who you were. It took a kind of marketing power that just wasn't available to small startups at the time. In retrospect, it is easy to see it as a losing game. Claiming to use superior hops and grains is meaningless in a world where 1) the major beer companies are making the same claim, and 2) they are a full three or four dollars cheaper per bottle at the bar.

Competing with big beer companies on their own terms could be done, but it was a rare, difficult road. In Delaware, however, the idea became to play a different game altogether. What would separate Delaware beer from much of the rest of the country was the notion that one could just walk away from the big beer game and play the big taste game instead. It was with this emphasis on taste, culture and practice that Delaware came to the table. Homebrewers are, first and foremost, about impressing themselves, or at least testing their limits. The real craft beer revolution would turn out to be more like catching a cold than adopting an ideology.

Craft beer became about hanging around and developing relationships with the beers and the brewers long before the first dollar was exchanged. Why try and beat big beer when it could be ignored to the same effect? But this attitude would be cultivated more accidentally than on purpose. At the center of the craft brewing revolution as it occurred in Delaware was an almost accidental innovation. This innovation proved to be the result of a struggle to stay open during difficult financial times.

Open for Business

In the late 1970s, a man named Peter Austin began brewing traditional ales in England that used what's called "open fermentation," a method that is as old as beer itself. Before people discovered how to cultivate yeast, beer was made by boiling the brew and letting it cool. The wild yeast that is in the air would be attracted to the fruits or other sugars in the beer, settle in the brew and begin making alcohol. Wild yeast, however, is unpredictable. Yeast is a

really significant part of a beer's flavor, such that the kind of yeast dictates a beer's flavor as much as the kind of malt and hops. This meant that using wild yeast meant taking chances with flavor.

As vintners discovered, particular yeasts could be cultivated to give specific flavors to their wine. In fact, the white powder you see on grapes is yeast. They discovered that yeasts could be tamed and refined, and beer was able to follow suit. Once the yeast was brought under control, it was only a matter of time before it was able to slide neatly into the industrial age. Brewers found a way to isolate a particular yeast for a particular flavor. The next step was to make certain that none of the wild yeast from the air invaded the purified yeasts in the beer. The result was the rise and proliferation of what is known as "closed fermentation." The yeast is thrown into a vessel and (essentially) sealed to prevent any yeast in the air from getting to it. As lagers rose to prominence, this became the dominant method for brewing.

Austin was a leader in what is called the real ale revival movement of the 1970s. He conceived of and constructed a brewing system and procedure that used the more traditional open fermentation but also reduced the odds of wild yeast infecting the beer. His Ringwood Brewery, which opened in 1978, set the standard for the revival in English ales. By the early 1980s, he had taken on a protégé, Alan Pugsley, and the pair traveled internationally, helping a new breed of brewer to open Peter Austin breweries. The craft beer revolution, as we've come to see it, was underway.

THE ENGLISH INVADE BACK

It's important to acknowledge that there still were small, independent breweries chugging along in the 1980s and that some of them were doing really interesting things with what they had. For example, Ken Grossman of Sierra Nevada Brewery in California hand-built an open fermentation system right around the time Peter Austin was doing the same. Eventually, though, Austin began manufacturing brewing systems and exporting them to the United States and elsewhere. This innovation removed the most difficult barrier to opening a small brewery. The second biggest difficulty was installing the system. Alan Pugsley came east.

Between 1985 and 1992, Pugsley helped set up nearly twenty breweries in the United States. Among them was his own, Kennebunk Brewing Company in Maine, and its attendant brewpub, Federal Jack's, which opened in 1992.

As demand outpaced supply, he and his partner, Fred Forsley, opened Shipyard Brewing forty minutes north in Portland (and a little more than an hour from a vacation spot called Dogfish Head). Rather than traipsing all over the continent opening breweries, Pugsley invited people interested in starting brewpubs to come to him and learn on the Peter Austin systems he had installed there. Among them were Sam Calagione and Al Stewart, the first two professional brewers in Delaware and founders of Dogfish Head Brewing and Stewart's Brewing Company, respectively.

While it would be inaccurate to oppose loosey-goosey English ales with staunchly predictable German lagers, it isn't entirely inappropriate. For better or worse, the Germans had a pretty specific way of doing things, and America in the 1980s and 1990s was just off the light beer invasion when Lite, Bud Light and Coors Light rose to nearly complete market dominance. The earliest part of the craft beer revolution introduced the notion of styles other than lager. In Cambridge, Maryland, not far from where Dogfish Head would be founded, Wild Goose, another of the Pugsley startups, had had some success with English styles that were bitter and still relatively low in alcohol.

Temperature was another important difference between the beers that had not been fully appreciated or communicated in those early years. The notion of European beers being served "warm" was possibly the most difficult thing for the newer beers to overcome. It's probably best to say that American lagers of the type the bigger breweries were selling were best served ice cold. During the latter part of the twentieth century, as beers got bigger and processes included more corn and less flavorful grain, it became critical for bigger breweries to associate beer with cold. As a beer warms, its flavor begins to come out; if there's not much flavor, or if the true flavor is unpleasant, it becomes more pronounced as the beer begins to warm. European beers, especially smaller brands, did better at higher temperatures because the flavors and complexities came better to the front.

In defense of the bigger beers, it was part of a larger plan to bring beer back to prominence in American culture in response to the rise of the golden age of the American cocktail. So beer had to draw a line in the sand. If cocktails were going to be about sophistication, then beer was going to be the drink of the working class. Beer would be the drink without pretense, something a person could pound down without concern about subtleties. It was the only market left to beer after alcohol ascended to legitimacy, and breweries took advantage of it as best they could.

So, as the craft fad took off in the 1980s, flavor and subtlety weren't associated with craft beer. In a world where one beer wasn't supposed to

Stewart's Brewing Company assistant brewer Eric "Bo" Boice in the original fermentation room. Although removable tops eventually were added to allow the brewery to use different types of yeast, it still uses the same tanks that came with the original Peter Austin system it had installed. It was the first in the state.

taste substantially different from another as a matter of practice, it became a bar to entrance. This was muddied by new breweries that were brewing with the same attitude as the industry standard. Craft beer quickly became synonymous with "pricey" beer and high margins.

Entrepreneurs saw the markup per pint and didn't often consider the larger expenses behind craft beer. Making these "better" English ales trying to use the American production model was where people ran into trouble in the late 1980s and into the 1990s. Beer isn't difficult to make, but making good beer that is worth the markup people believed it could get is a little harder. "People realized how much it cost to brew beer," Al Stewart said of that period. "If you want to buy guys who can 'make the donuts,' you can, but if you want guys that can put medals on your wall, it can be expensive."

The American Way

When it comes to American culture, and American craft beer in particular, "If a little is good, more must be better" is an aphorism that stands both as criticism and praise. There are a lot of things that happened in the 1990s that hurt craft beer. Although quality control is the most cited, it isn't necessarily the primary reason.

Small breweries had their eyes on national and global markets in a way that was unrealistic and also failed to address what made craft beer successful. It isn't hard to see the local connection in retrospect, but at the time, many breweries believed that they could grow indefinitely and mortgaged the present to a future that wasn't strictly speaking possible. Overvalued brands were purchasing other overvalued brands and driving up costs without increasing yields. A relatively famous example was the demise of Wild Goose, a brewery that was born on the Delmarva Peninsula and rose to significant notoriety.

Wild Goose was one of the early Pugsley breweries, and it was successful but also costly to run. In the late 1980s, it was being run by a man named Jim Lutz, who would go on to have one of the storied careers in craft brewing. Against his advice and lobbying, the principals sold Wild Goose to the Frederick Brewing Company, and as part of the consolidation, it moved the brand off the peninsula and into its massive new building in Frederick, Maryland.

Many people have said that Wild Goose was inconsistent toward the end and that this was the reason it eventually failed as a brand. This only is barely true. Frederick used a closed brewing system. The Wild Goose beers were designed with open fermentation, and the yeasts that thrive that way, in mind. Pugsley tried to convince the new brewers that changing the process would make the beers impossible to reproduce on a mass scale. His advice fell on deaf ears, and people who were fans of the beer soon began to notice the difference and stopped buying.

Brands that followed this pattern all over the country suffered the same fate. Others just expanded too rapidly and couldn't adapt to the pressures of the mass market. So, when it came to production and growth, more wasn't better. Experimentation, however, was a different story altogether. If a little experimentation with styles and production models was good for craft beer, more would be a lot better, especially when it came to Delaware beer. The two people who set the standard for the way beer would be done in Delaware right from the start, Sam Calagione and Al Stewart, took different approaches to the "more is better" attitude that shaped what Delawareans would take as the template for craft brewing culture.

Base Players

Delaware was pretty far behind the curve when it came to breweries. While the craft craze swept the country in the 1980s and 1990s, the Diamond State remained apart. Much of it likely had to do with the risk-to-reward ratio. Although it was a financial center, Wilmington was still on its heels, culturally, as a small city. Delaware is touted as among the most business-friendly states in the union, but the knot of Prohibition-era laws was daunting for many. Prohibition-era laws didn't stifle homebrewing though. The state had a strong, enthusiastic homebrew culture that grew up around Wilmington. Homebrew supply stores were busy and doing brisk business as people discovered the pleasure of making their own beers. There were several active homebrew shops and communities in the state in the early 1990s but not one brewery.

Homebrewers are among the most collaborative of hobbyists. They tend to put the practice of making great beer and solving brewing problems for the community ahead of ego, or at least ahead of recognition. Solving a problem or helping a fellow goes way above and beyond getting credit.

Small systems—like the one used in Twin Lakes Brewing Company when it was founded in Greenville—became the heart and soul of the craft beer revolution in Delaware. Taking a cue from the homebrew culture, brewers all over the state made small batches of beers that were variations on traditional flavors. This meant that beers became distinctive and niche while still gaining popularity throughout the region.

Today, the homebrew culture in Delaware remains outrageously strong and has not only produced most of the brewers and brewery owners in the state but also helped perpetuate the region as a craft beer stronghold. Two of the foremost homebrew supply purveyors and craft beer mavens at the time were Doug Griffith and Ed "Eyeball" Siccardi Jr. These men, along with others who frequented their shops or opened shops of their own, helped to form the nucleus of the exploding homebrew culture. Although they aren't the only two, they do represent an archetype: people who love craft beer so much that they work to make it better for the love of it rather than for money.

Doug and his wife, Patti, began as avid homebrewers and winemakers in the mid-1980s, and eventually it became a primary theme in their leisure time. The pair made finding breweries and tasting beers a regular part of their travels here and abroad. Doug made friends with other homebrewers, and when he made trips to homebrew stores in Wilmington, he often would pick up supplies for others as well. Eventually, it became easier to order in bulk and sell out of the converted shed in his Millsboro, Delaware backyard, and so Delmarva Brewcraft was born.

Over the first few years, Doug and Patti developed a significant following. A Saturday morning at their home was less business and more gathering. Often they would cook, and homebrewers would come to ask questions or buy supplies. Eventually, Doug started offering classes so people who were interested could get practical experience in brewing before they committed to purchasing all of the equipment needed for homebrewing.

As a hobby, homebrewing can swallow up and inflame the passions of people like few other diversions can. Enthusiasts are constantly trying to make themselves better through practice, lessons and communing with other brewers. As hobbyists, homebrewers also are always searching for ways to cut costs, since purchasing new brewing gear can get expensive. In this way, Saturdays at Doug's were like a combination golf outing and remote control convention. Some knots of people would talk about what they were doing to improve their process and others about how they had jury-rigged their gear.

Doug was at the center of all of it, continuing to learn and help the homebrewers, as well as brew and develop his own recipes. Doug's was the center of the Sussex County brewing world, and so when word reached him that a brewpub might be opening in Rehoboth, only half an hour or so away, he went to see it for himself.

Beach Town Brewing

Sam Calagione started homebrewing in New York while he still was working as a bartender there. It is hard to imagine a bartender who didn't have a great idea for running his or her own bar, but the fun that Sam had homebrewing informed his dream in a way that would set a permanent imprint on craft beer, writ large. For him, it was about the flavors and experimentation. As he set out to open what would become Dogfish Head Brewings and Eats, much of what he did would be informed by the homebrew aesthetic.

After searching for the right spot for what he had decided would be a brewpub, Sam and his wife, Mariah, decided to focus on opening a place in Rehoboth, where Mariah had grown up. They chose a beach town, and in that beach town they chose a building that had been one of those that had serial bar and grill failures. It is a testament to the American spirit that there exist buildings in every town in the country that are known to be the homes of failed restaurants. When a new restaurant opens where one has just closed, the neighbors tend to roll their eyes at the idea that this new concept will work where all the previous concepts had failed. Successes like Dogfish Head Brewings and Eats are the

The iconic bandstand at Rehoboth Beach isn't the only icon in the beach town. Dogfish Head Brewings and Eats, located more than a few blocks away, has become a year-round destination for people who want to visit the storied brewery.

exceptions that enforce the notion that locations aren't necessarily cursed, only ideas or work ethics are doomed to failure.

Even though it was the height of the craft beer boom, everything about the building and location was not quite right. First off, Rehoboth was a beach town that was practically closed from October through April. What separates brewpubs from beach town restaurants is that they have to operate all year long. A restaurant could close for the season—a brewpub had to constantly make and serve beer to thrive. This has as much to do with the economics of brewing as the skill involved. Waitstaff and other kitchen help don't require the technical know-how that brewers do. The notion of getting people to come to Rehoboth was daunting for restaurants that weren't already taking chances on making their own beer.

Another problem was that brewing wasn't technically something that people were allowed to do in Rehoboth, and bottling beer brewed on premise wasn't something that restaurants were allowed to do in Delaware. Fixing this set Sam off on a legislative journey that would establish a template for many of the breweries in the region, including the Eastern Shore of Maryland, as they continued to try undoing Prohibition.

From the humble beginnings of a single-batch system, Dogfish Head has grown to become one of the largest, most respected breweries in the country, producing about 500,000 barrels in 2013.

Prohibition had been fully repealed more than half a century before, but the laws that led up to Prohibition hadn't. Many of the statutes enacted as part of the temperance movement to reduce drinking, and which were aimed at placating the zealots who eventually pushed for total prohibition anyway, remained in place. Nearly a full century later, in some parts of the country, these remained the barriers to opening breweries and brewpubs. Later laws aimed at reducing the stranglehold that breweries had over taverns also had to be dismantled. For Sam's purposes, brewing was the most critical part—once he was allowed to brew and to sell what he brewed, the rest could be handled as needed.

Getting the laws changed was time-consuming, especially for a young entrepreneur who was daily bleeding money, but it wasn't impossible. As it turned out, Delaware was amenable to having brewpubs and eventually breweries and distilleries open in the state. In fact, as Sam worked with his lawyers to draft legislation that would allow him to start brewing, bottling and serving, there were other entrepreneurs in the state waiting to do the same thing.

BACK TO THE FUTURE

The reaction against big beer was cultural as much as it was philosophical. Craft beer proponents didn't just want better beer—they wanted to participate in a culture that had been all but completely lost to them, one where the tavern was relocated to the center of town. Although Delaware was late to the first craft beer revolution, it would prove to be well ahead of the curve when it came to the second.

From time immemorial, the tavern was the center of city life. One fact that Delaware understood early was that brewpubs were more like the taverns the predated the proliferation of regional beers than the saloons that followed. Beer would be the centerpiece, but gourmandery would be the point. While breweries elsewhere in the country were buying and selling one another with increasing regularity and decreasing success, the hope from the Delaware brewing community was to take a different tack altogether.

Food was critical and made the earliest brewpubs a much easier sell to those who were worried about too many people drinking on an empty stomach. In fact, it was around this time, toward the end of the first craft beer boom, that the comparisons between craft beer and wine started making their way into the public consciousness. As likely a part of the improving economy as a function of the baby boomers ascending into middle age, craft beer was

added to the ranks of cigars, whiskey and wine as a demarcation of middle-class refinements. "Foodie" hadn't risen to common use yet, but restaurants loomed larger in people's imagination than they had in recent memory. The notion of the complete food sense experience also came to the fore, making the suggestion of a midscale restaurant that focused on beer as well as on food appealing, if not completely exciting.

In Delaware, diversification was more important than anything aesthetic. Although there was a very small beer tourism culture (as evidenced by people like Doug Griffith), it would be another decade or more before anyone would begin to consider that people might travel great distances for a particular beer experience. There was no sense of competition in the way there would be among municipalities as the second craft beer boom started in the twenty-first century. Instead, clearing the way for brewpubs was a statement about the state's reputation for being business-friendly.

Laws that were nearly a century old were preventing businesses from opening and functioning. These laws could be removed or relaxed with little chance of public harm and, at the least, the opportunity to increase the tax base. As 1995 approached, there was a movement underway in three separate places to reestablish the tavern as the center of culture. They only needed clearance from the state.

THE OUTSIDER'S OUTSIDER

Al Stewart was as committed to the taste experience as much as he was to the leisure culture. Beer for him might be called the umami of a great meal, a kind of surprisingly essential part that would be best noticed by its absence. Al was the only non-homebrewer brewery founder in the state and one of only a handful in the country. He was a craft beer enthusiast from early on and understood craft beer's inherent possibilities in an important way. A chemist by training and businessman by trade, he and his brother, Greg, had planned to open a brewpub in their native New Castle County while both still were students.

Al was, at the heart of everything, a restaurateur. He had a vision for what a restaurant should be and what a bar should be. He understood that there should be a unity of effect entwined throughout an entire project. Mostly, though, as he and his brother planned their new place, he got that if he could make his own beers, he could create a singular

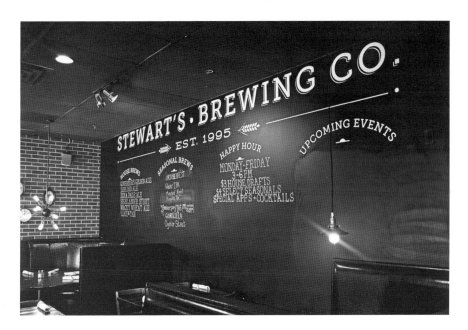

Stewart's Brewing Company was built with the consistency in vision in the way that the food related to the beer and vice versa. It helped establish that brewpub as a place where better food and better beer became the norm.

dining experience. It was one of the approaches that set the Stewarts apart from the very beginning—the beer and food would inform each other rather than one being more dominant. Eventually, the brewpub would reach the point where the brewer and chef would consult regularly when planning their respective menus.

Sam Calagione wasn't the only person working to change the laws. There were others who had been lobbying for a while. Sam's innovation was that rather than just lobby, he helped write the legislation, which saved the legislators the difficult work of writing laws. There was change in the air for a long time before Al and Greg scrapped their brewpub idea and began looking for something else to do. But no sooner had they given up than the beer and brewing laws changed, and what would come to be called Stewart's Brewing Company was off the drawing board and into early production.

Al ordered a Peter Austin brewing system and got to work finding a place to open shop. He knew that he wanted to be in Newark and settled on a place, but when that fell through, he went searching for another. In the meantime, there were other concerns, like how to make beer. Stewart's Brewing Company was to be as traditional as it got.

Because he had no practical homebrewing experience, Al wanted to focus on the traditional. He intuited a premise that since has become something of the standard in the craft industry: fresh beer with quality ingredients is superior. As part of his purchase of a Peter Austin system, he was invited to go to Kennebunk Brewing to learn how to use the equipment used there before the system he ordered arrived. Al wanted to leave with the ability to make four simple beers. In the meantime, they had settled on a building that also turned out to be the antithesis of the brewpub template: shopping center frontage in the nearby town of Bear, Delaware.

For brewpubs today, the mystique is an important part of the image. As innovators, and Delaware brewers are nothing if not creative, brewers tend to select buildings that give them plenty of room to be creative with their décor and room for expansion. The first three breweries in Delaware, however, didn't follow that pattern. Dogfish Head opened in a former restaurant and bar, and Iron Hill, the other Delaware brewery in the works at the time, also chose a storefront.

What makes this significant is that all of these choices indicate a particular commitment in that none of the first three brewpubs in the state was large enough to accommodate production-scale equipment. The traditional brewing tanks used for storage and fermentation are in the twenty-foot-tall range. The smaller tanks that are part and parcel of a brewpub setup are more in the eight-foot-tall range. From the perspective of legislators, and for the brewers themselves, these were not the kind of breweries that were going to produce enough beer to be distributed internationally. They were the kind of facilities that could make enough beer for the immediate area, just like the taverns of the nineteenth century.

New Pubs, No Beer

When the law was changed and the race was on to start brewing beer, Delaware primarily was a pub state. Al and Sam each got his liquor license at essentially the same time, but while Al was waiting for his equipment to clear customs, Sam started brewing beer homebrew style.

Al said that to this day, he isn't certain why his equipment didn't come, but it is amusing to imagine custom officials scratching their heads at the sight of brand-new, large wooden tanks with brass and copper fittings, trying to calculate whether they really were for beer making. At any rate, Al started bleeding money of his own—in his youthful exuberance, he had planned in one extra month as

padding to get the brewery up and running. The result was that eventually they had to Stewart's Brewing Company without the brewing part.

Al and Greg Stewart played the cards they had been dealt and began serving all the craft beer they could get their hands on while they waited for their own brewery equipment to arrive. They were the darlings of the local distributors because they were going through such quantities of craft beer. The way they figured it, it was in their best interest to promote craft beer as an option and establish the market where their beer eventually would be sold. It worked.

Early on, Stewart's Brewing Company also developed a comprehensive if subtle pairing menu. The food it served was complemented by the beers on tap. The plan was to get the waitstaff as much as the customers to think in terms of tastes—which beers go best with which meals.

Once his tanks arrived and he could begin brewing, Al learned to work with the chef so that the menus still were beer friendly. When he started making his own beer, he stopped serving as many other beers, which came as something of a blow to the distributors. He'd been honest from the beginning though and even warned them as the new brew system was being installed that he was only weeks away from going from consumer to supplier.

It is the rare brewer who can have success on a new system in the first go, and here Al was at an even more distinct disadvantage. While down in Rehoboth, Sam was having success at continuing his homebrew tradition, and Al was learning to homebrew on a seven-barrel system. While Sam had plenty of his own issues, whatever mistakes he made were ten gallons at a time, whereas Al's mistakes were made more than two hundred gallons at a time. Throwing out bad batches of beer can get expensive. Worse (and this is common to nearly every brewery) was making something great by accident. It is quite common for new breweries to mess up a recipe that turns out to make an even better beer than expected. The trouble is that, oftentimes, the mistake can't be repeated because the precise thing that caused it can't be duplicated.

Also, the Peter Austin systems were created with the artisan beer maker in mind. They didn't have the kinds of bells and whistles that would keep a person, say, from freezing an entire batch that he was trying to cool. Brewing on a Peter Austin system was much more like tuning a guitar than playing a record, and the learning curve was something with which Al struggled. Fortunately, he had a little help from an interested engineer.

Ed "Eyeball" Siccardi Jr., like Doug Griffith, was something of a modern-day Renaissance man. An engineer for Du Pont at the time, he also ran a homebrew store and strung instruments. He found his way into Stewart's and began tinkering—at Al's invitation, of course. Eyeball invented or

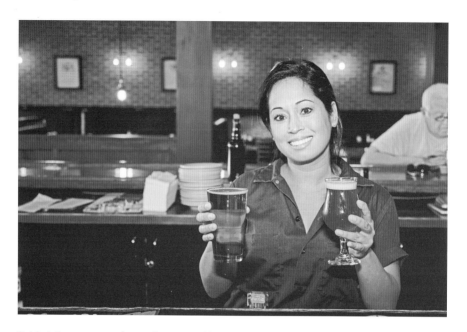

Behind the taste experience, the most critical part of an enduring craft beer revolution is knowledgeable servers—people who can guide initiates into the craft beer world. Al Stewart made an effort to retain more highly qualified bartenders like Christina Vidal, by offering things like benefits and other incentives that are front-loaded costs but also pay returns in improved experiences for people learning to appreciate craft beer.

fashioned different controls, figured out a way to allow Al and his brewers to switch between closed and open fermentation, depending on what they wanted for the beer they were making, and generally made it easier for Al to brew without endangering his livelihood.

Stories like this are repeated at nearly every brewery and certainly will continue to be a part of the craft beer revolution going forward. There is a barely intelligible cool factor associated with making your own beer that people want to be a part of. But it is something more than being cool; it is the opportunity to be a part of something bigger that isn't really available to everyone else. Even if the United States surpasses 5,000 breweries (in 2015, the number was approaching 4,500 breweries), that still isn't very many compared to the number of people. There are about twenty thousand towns in the United States. Having a role to play in your town's brewery is, in a sense, a civic act that hasn't been available to regular people for more than 150 years. Homebrewers and weekend tinkerers are drawn to breweries with the intention of helping or learning or both, and it is only in retrospect that anyone gets a sense of how important their contribution is.

All Hands on Deck

Off-Centered

Although Sam Calagione had trained at both Shipyard and Kennebunk Brewing, brewing his own beer on his own system was another problem altogether. First of all, he didn't have a professional setup. Dogfish Head (now famously) started with a homebrew setup making ten gallons at a time. Moreover, there still was some construction to be done, and the floor plan for what would become the brewery wasn't right. It was here that Sam had the good fortune to have an ally in the homebrew community and, particularly, in Doug Griffith.

There is a half-generation of brewers, including people like Doug and "Eyeball," who missed the brewing boom opportunity in Delaware as much because of the laws as anything else. Sam Calagione will always have credit for popularizing craft beer and for innovating that culture in such a way that the homebrew and professional brewer culture essentially became the same thing. But his true legacy (and many might say genius) was in rewriting the legislation. The craft beer revolution wasn't about people accepting the improved quality of beer as much as it was people accepting the improved opportunities that came with a little legalization.

The pressures that come to bear on any entrepreneur always are enormous. Even eternal optimists will admit that the distance between an idea and a successful business, or even a self-sustaining business, is immense. This is true because every new business can only succeed by convincing

people to reallocate some of the money they were spending elsewhere. There is marketing and business planning, insurance and taxes and a million other things that even the most diligent entrepreneur doesn't consider. Now imagine that, on top of the standard bars to entry for every entrepreneur, what you want to do isn't legal and hasn't been for two generations or more. Imagine having to fight city hall for the right to see whether or not you will join the ranks of thousands of failed businesses. From this perspective, it is pretty easy to just find another way to do things. Sam has never been shy about spreading around the credit for the end of his accomplishments, but the vision to undertake them has to lie with him exclusively.

It would take nearly a decade, and this is something we'll return to in another chapter, but the success of Dogfish Head was inspirational not only to other brewers but to other states and municipalities all over the region. Outlining the pattern of supporting lobbying efforts by supplying suggested legislation made it possible for dozens to see a way past government regulation, stonewalling or ignorance. This isn't to say that if he had failed, his failure couldn't have been improved on by others following the same template—only to point out that his success became Exhibit A as brewers around the state and region later began writing brewery legislation to undo the damage done in the rush toward Prohibition.

As it happened, however, Doug was not a professional brewer any more than was "Eyeball" when they started pitching in at Dogfish Head and Stewart's Brewing Company, respectively. Both, however, had been homebrewing for long enough that they had found ways to make things they couldn't easily or conveniently purchase. Both were in other professions that gave them additional skill sets. In Doug's case, it was IT with a heavy dose of construction. When he started coming around, his skills weren't an issue. He was just there to paint and help with the brewing after it started. One day, Sam was talking to him about how they could redo one of the rooms. There was a post that was in the way, and Sam was trying to figure a way to configure the room to avoid the post. Doug suggested an alternative: move the post. Together they reconfigured the room, but along the way, they also reconfigured Delaware beer.

Doug has something of a mantra that he repeats to all the homebrewers who come to his shops for help, criticism and encouragement when they have a batch go awry: "It's still beer." There is something Zen in embracing that realization. Dogfish Head has made a name for itself by taking risks with beer such that it has created a culture shift more than merely an approach. Trying big also means failing big, and there were a number of beers that

never made it past the pilot stage—there still are. But the fact that Sam was working ten gallons at a time rather than two hundred emboldened him. After all, a failed batch still was drinkable at an investment of about $100 rather than $2,000.

By the time Dogfish Head opened, Sam had settled on several beers that were odd and several more that were reliable, most notably the now famous 60 Minute IPA. But he couldn't keep up with demand. He was bottling as well and selling beers like Wild Goose out of nearby Cambridge, Maryland, and Stoudt's out of Adamstown, Pennsylvania, to ensure that he always had beer for his patrons to drink.

Both he and Al over at Stewart's enlisted all the volunteers they could to help brew and keep up with demand. Both are adamant and proud of the fact that neither Doug nor "Eyeball" pay for beer at their places because of their respective contributions. While the beers at Dogfish Head, Iron Hill and Stewart's are all award-winning and recognized, early on it was the food that built the bridge between staying open and not.

PRODUCTION JUNCTION

For years, Dogfish Head was considered the smallest production brewery in the United States. In its second year, Sam (with Doug's help) built a seven-barrel system and began pushing for wider distribution. Similarly, Al was starting to get his beers into different places, but in Newark, Iron Hill Brewery was open and doing none of those things.

Production was okay, but the profit and the satisfaction was in pouring beers for people who made the trip to the brewpub—and they would make it for food as much as for beer. Iron Hill's business plan was to have a brewery that made world-class beer for people who walked through the door and for almost no one else. As Stewart's and Dogfish struggled to balance distribution with service at the restaurant, homebrewers Kevin Finn and Mark Edelson were developing recipes for the Iron Hill brewpub in Newark that they recently had opened with restaurant veteran Kevin Davies.

For people who have watched the craft beer revolution unfold and the notion of locally brewed beer take off, the fact that more people haven't adopted the Iron Hill model is mindboggling. Over its first decade of business, Iron Hill exported breweries instead of beer, settling on proven food and beer recipes as a base but allowing the brewers a relatively free

The Iron Hill Brewery in Wilmington has become its own destination brewery and something of a centerpiece for Wilmington's redeveloped riverwalk.

hand to experiment at each of the locations as the brand expanded. While brewers throughout the region fought with distributors and distribution rules and practices, Iron Hill used the brewpub allowances already in place to build a particular brand for a particular clientele.

Just as with Stewart's and Dogfish Head, Iron Hill focused on the food as it related to the beer. But its innovation was to borrow not from the big beer model but rather from the big food model. It built a culture around its brand such that people who worked for it and who dined at its various restaurants in Delaware and Pennsylvania had general expectations about both the beer menu and the bill of fare but also understood that each restaurant would be better off doing what it did best rather than what another restaurant in another part of the state or region did best. And Iron Hill did it as well as anyone else could.

Over in Bear, Delware, Al Stewart was facing problems of his own when it came to distribution. He'd bought out his brother, Greg, and as he took over the entire operation, he had to place greater and greater reliance on the brewers he hired. He had gotten a contract to be the "local beer" for the Wilmington Blue Rocks and was producing a special lager for the team to sell at the stadium, but he wasn't really making much money on the deal

and worried that it devalued the beer. The point of craft beer, especially for Stewart, was that it was a premium product. Sure, it was inexpensive in the brewpub, only a few feet from where it had been brewed, but once the beer was out in the world, it wasn't there to compete with Miller Lite. It was out there as a demonstration of what a better version of a lager could be.

On the eve of the craft beer bubble popping in the late 1990s, there were too many breweries racing to the bottom when it came to quality and racing to the top when it came to quantity—and distributors were still hounding Al for more beer. If he had quadrupled his output, he still wouldn't have been able to meet the demand. He also was going through brewers quicker than he would have liked. Then he caught his breath. He didn't get into this business to do what other people told him to do, and with that realization, he pulled back and reorganized in his head and in his business. He put on the brakes when it came to distribution and rethought everything.

What makes Delaware a singular state for craft brewing and what makes craft brewing a singular profession outside the arts is that the people who stay in it the longest do so because they're doing what they want to do, not what they have to do. Once brewers discover their voice, much like musicians, they continue along doing just that. They make what they make for the people who see things their way. As long as they don't betray themselves, they get along just fine. The best of them find a middle ground.

It likely is easier for those with more of a homebrew background, which is why Stewart's and (later) Fordham and Dominion are outliers. Homebrewers make what they think they will like, and if other people like it, they continue making it. But there's no point in making a ton of beer that you can't share.

Al didn't want to be one of the new beer barons. He didn't begrudge the notion, but the distance between what he wanted to do and what he would have to do to become a major player was one he didn't want to traverse. To this day, he says that he might be open to starting one more Stewart's Brewing Company, but if he even gets there, that is where he'll top off. Instead, he looked around at what he was doing and said that it was enough to have people who wanted to come in, have an outstanding meal and try his beer. He would make beer for them. And his new assistant brewer, Ric Hoffman, was already making beers that knocked their socks off. Ric was elevated to head brewer and commenced to do his thing. Al ceded the rest of the state and the country beyond to those more interested in conquering it. As it turned out, there weren't too many takers, at least in the first decade.

Because of the connotation, Sam Calagione certainly would resist the beer baron label. He wasn't pressuring or blackmailing saloonkeepers for

one thing. For another, he had the same kind of musicianship approach to beer that has made the strongest of the craft brewers able to survive the crashes, twists and turns that was craft beer from 1995 through the first part of the twenty-first century. His beer was for the people who liked it. He had no animosity for those who didn't, but neither had he any inclination to trick them into being fans. Dogfish Head would undeniably exist on its own terms.

Where the brewpubs continued to focus on making their food and beer compatible, Sam began working on describing how his beers were compatible with other people's foods as well. He made a full-court-press showing up at local and then regional bars to share a case or two of 60 Minute with the staff and talk about how it improved or at least augmented the dining and drinking experience.

As the brewing staff increased to multiple shifts, he maintained the balance between homebrewers and pro brewers who could keep things creative and also reproduce well-tried beers. When Ric came to Stewart's and changed the arc and culture there, he already had been a journeyman brewer. He was a professional for hire, and he worked out brilliantly. Dogfish Head had been a different beast from the beginning. New brewers could bring the beers they had made at home to demonstrate their abilities. Also, brewing hadn't quite hit yet; many of the people who had been "making the donuts," as Al said, returned to their day jobs as the craft beer bubble burst at the end of the 1990s. This just left people who were passionate about brewing and being creative to fill in the positions that were left.

As 60 Minute gained popularity, Sam had a decision to make about production, and it was one that informed the way the company did business, as well as the way people who followed in his footsteps did business. This is where the beer baron comparison isn't completely inappropriate. Dogfish Head made a lot of good beers, not just 60 Minute IPA. To this day, the brewery keeps 60 Minute below half of its distribution as a way of keeping the rest of the beers vital. Distributors who only wanted to sell 60 Minute IPA met with some resistance. "Anybody can sell 60 Minute," Sam later told a budding brewer who asked for distribution advice. "You have to make sure the distributors agree to carry all of your beers."

Since 60 Minute always would sell, Sam was able to use it as a fulcrum to lift other beers to prominence. In this way, he worked to ensure that Dogfish Head wasn't 60 Minute but rather that 60 Minute was an entry-level beer to what Dogfish Head made possible.

In 1996, Dogfish Head was the smallest production brewery in the country. In 2015, it was the thirteenth largest, with 60 Minute IPA accounting for

The oak fermentation tanks at the new Dogfish Head facility in Milton are massive and have the entire room to themselves. A tricky part of expansion for Dogfish Head has been finding a way to innovate without compromising the underlying attitude of making solid beers.

something like 48 percent of total sales. It's a rare Bob Dylan concert that doesn't include "Like a Rolling Stone," but it is an even rarer one that doesn't promote music from his latest album.

"PLEASE BREW BEER"

The fact that so few people know who Jim Lutz is in comparison to guys like Sam Calagione, Jim Koch and Ken Grossman is a testament to how excellent he is at his job. Like Al Stewart, he wasn't a homebrewer but made the kind of inroads into craft beer and, really, beverages in general that only makes sense in the big picture. Moreover, he has been a driving force behind the craft culture since the 1980s, when he came to Delmarva to run a relatively new beer company on Maryland's Eastern Shore called Wild Goose.

A Milwaukee native, he started his career at Pabst after graduating from the University of Wisconsin. He left Pabst to sell Crystal Geyser bottled water back when the notion of people paying for something like that was

laughable. From there he got into the distributing business, first as an employee and then with his own company, with which he had secured the rights to bottle Stewart's Root Beer (an East Coast brand unrelated to Stewart's Brewing Company). As part of his Colorado-based company's work, he began distributing Pete's Wicked Ale, so he already saw craft beer's potential.

The thing that he got about craft beer, right from the first, was that it was a team sport. When Alan Pugsley left Wild Goose to start what would become Shipyard Brewing and Wild Goose was scrambling for someone to run it, the company's board of directors turned to Jim. Not being a homebrewer is different from not knowing how to brew beer, and Jim knew how to make good, consistent beer in the tradition of the best big beer manufacturers. Living in Colorado at the time, however, and seeing the rise of Pete's Wicked Ale, among others, he also knew about the potential for craft beer.

Jim's true skill, though, was understanding what might be called quality trends and their limits. That is, he knew that being good or even great was no use if your greatness was a secret. So when he ran Wild Goose, he didn't tout exclusivity so much as he touted quality. The kind of person who knew to drink better beer also knew to order better food. Additionally, he did all he could to encourage other brewers in the region to do the same. When Sam Calagione came in to see the operations, Jim welcomed the notion of another brewer in the region. Although neither Sam nor Jim recall it clearly, Doug Griffith was on that same tour and remembered heading to Cambridge to get some yeast and look over the facility.

The fact that Jim doesn't remember the encounter didn't surprise him, so hectic were the times and frequent the visits. "It was like, 'Anyone, please brew beer!'" he said of the period. He understood that the more people who were knocking on tavern doors selling craft beer, the more credible all of the sales were.

Jim elevated a brand that was being made in what amounted to a barn in one of the most depressed cities on Maryland's Eastern Shore into a beer that, as was mentioned earlier, rose to a level of prestige that only could be measured in the rate of its descent. When Wild Goose was purchased by Frederick Brewing Company, he didn't last long and was, in fact, paid to leave. Jim wasn't the kind of guy who could go along while people made his beer worse, and although he didn't start or own it, Jim Lutz saw Wild Goose as his beer.

During Prohibition, many of the biggest breweries got into the ice cream business, using the refrigeration tools and distribution skills that

Brewer Dan Lauder, President Jim Lutz and Marketing Director Ryan Telle have worked together to transform two regional brands into a local beer, which was no mean feat. Along the way, the Fordham and Dominion Brewery has become a centerpiece for the Dover craft beer community.

they had to float their businesses while the storm of Prohibition passed. By these lights, it is more than a little amusing that Jim bought some Dairy Queens in the region and ran them for a few years, until Frederick crashed and was eventually bought by a Colorado brewery, Flying Dog, for an East Coast relocation.

Flying Dog, with its avant-garde label art and its ties to Hunter S. Thompson, didn't make a lot of friends with its move east and needed someone who knew what he was doing in the market. Flying Dog impressed this need on Jim, who once again was drawn into the brewing business. It was there at Flying Dog where he got something about the labels that hadn't occurred to him before: he was passing out of official relevance when it came to the beer market. The odd labels and the colorful names didn't entice him, but they weren't meant to. He already was a craft beer enthusiast. If craft beer was going to continue to grow, it had to find new adherents, which meant finding new enticements.

"He Was Just a Bad, Bad Guy"

When Jim came east in the 1980s, he gave up skiing for sailing. It's a transition he is fond of talking about. In Maryland, sailing means the Chesapeake Bay, and it also means spending a significant amount of time in Annapolis. There he befriended Bill Muehlhauser, owner of the storied Ram's Head Tavern and startup Fordham Brewery. Annapolis is as much about history as it is about maritime living, and Fordham Brewing was named after Benjamin Fordham, who, legend has it, was given permission to start the colony's first brewery by the queen and went on to steal from his friends and sleep with their wives until he was a failure and a disgrace. Still, first is first, and that's the name Muehlhauser wanted for the brewery.

Farther south, Old Dominion Brewery of Virginia was looking to sell. The ownership there smelled the end of the craft beer boom and wanted out, and Muehlhauser was part of a concern called Coastal Brewing. Through a long, vaguely convoluted series of events, Fordham had made a deal with AB InBev, the company that owned Budweiser, to get national distribution and cash. This meant that Budweiser (essentially) was a stakeholder in Fordham and Old Dominion just when being an independent brewery came into fashion.

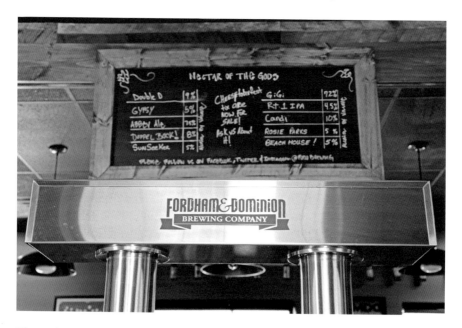

The tasting room at Fordham and Dominion Brewing is small, but its purpose is to introduce people to the beers, not really to be a hangout. The hanging out is done on the massive property outside.

Fordham decided to close the Old Dominion Brewery and the Annapolis brewpub and move the whole kit and kaboodle to Dover. Things were looking bleak for the company, so Muehlhauser reached out to Jim to see if he would come aboard and effect a turnaround, or at least stop the bleeding.

It wasn't an easy decision, but neither was it too difficult. Jim was happy at Flying Dog, which was and remains a brand on the rise. But if there is a pattern in Jim Lutz's career, whether it is selling bottled water or establishing a beachhead for high-end beer in a world where Coors Light is king, he likes a challenge. And Fordham/Old Dominion beer at the time was a challenge worth accepting, so he did.

It is something of a point of pride for him, and a bit revelatory for the culture, that Jim makes it a matter of policy to take cabs when he's drinking. Caution about drinking and driving is something all of the craft brewers take seriously because it is another way to set themselves apart from the massive brands. Craft beer isn't about getting loaded, but getting a little tipsy can still be a result. Think of craft beer as grownups making grownup decisions about what they drink and how they handle themselves. So, upon arriving in Dover, he asked a cabby, a self-proclaimed lifelong Doverite, where the brewery was. The cabby told him there weren't any breweries in Dover.

"It's my nickel," Jim told him. "Let me show you."

A MILE DEEP AND AN INCH WIDE

Jim came to Fordham and Old Dominion in 2011 under less-than-ideal circumstances. The brand didn't have a bad name, really, except among the anti-Budweiser folks, but neither was it distinguished. This wasn't Jim's first rodeo, and if he had learned anything from the previous decades, it was that craft beer was personal, relational. If people didn't know that their town had a brewery, the odds of it having that true artisan feel went down dramatically.

Fordham and Old Dominion beers were distributed all over the country, and they were doing okay but not spectacularly. They weren't located geographically, and they didn't have anything to distinguish them, per se, beyond their inherent quality. When he was at Wild Goose, Jim knew that being better than most beers was enough. But now, at the height of the second craft beer boom, being good wasn't enough—there had to be something that enticed people. The first part of kick-starting that enticement was getting people to develop a relationship with the beer, the brewery and the culture.

The second part was getting others to try it blind and impressing them. Jim took a first-things-first approach.

There's a mythology of big versus small corporate, but practically, if no one is invested who also has an endgame in mind beyond the bottom line, it doesn't matter how many vice-presidents a company has. Fordham and Old Dominion had been profitable enough, or not too unprofitable, that they hadn't had a lot of corporate attention. The beers were still excellent and the employees still committed to making great beer. Fordham never lost its English edge. Many of its English ales were low alcohol and had been since their inception. "Sessionable" beers—beers designed to be drunk in quantity without getting you too drunk—had been its wheelhouse since before the term was coined, but not a lot of people knew about it. Just looking at what was going on, Jim was able to go down a mental checklist and fix the obvious troubles right off the bat.

The first order of business was to refocus the beer's reach. They were distributing to states that didn't need Fordham or Old Dominion brands but wanted the cache of large selections. Pulling out of wide distribution was as much about eliminating distractions as it was about establishing a new focus for Fordham and Old Dominion, which also started going by FoDo on social media. Contracting was only a minor part of the refocus. Improving community support was the big thing.

Today in Cambridge, Maryland, if you find someone who remembers when Wild Goose was producing beer there, he or she remembers the brand fondly. When the brewery closed and moved to Frederick, even though it didn't cost a lot of jobs, there was a huge community backlash. Residents accused the city council of not trying hard enough to keep the brewery in town. Today, in a world where being able to identify your hometown with a brewery has even more social cache than it did in the 1990s, becoming Dover's "town" brewery was something to be desired and focused on.

The first order of business was to increase the number of people who took tours and visited the tasting room, and the second order of business was to reestablish the beer garden culture that production breweries around the state were just starting to reproduce. Jim espouses an aphorism that goes, "It they touch your tanks, they'll buy a six-pack." What it means is that once you can get someone to be personally invested in your beer, they will want it even when they're not at the brewery. Especially as craft beer began to get really popular among even occasional craft beer drinkers, it took on the mystique of a sports team. People want to elicit a little bit of jealousy when they can say that a popular brewery is in their town or that they've been to

In addition to the beers, Fordham and Dominion have gotten into the craft soda production and distribution business. Jim was one of the people who brought Stewart's Root Beer (an East Coast soda brand) out of the restaurants and into bottles, so he already has the requisite soda experience to pull it off.

a particular brewery. In 2010, the year before Jim came on at FoDo, one thousand people took brewery tours; in 2014, ten thousand people did. And the beer grew accordingly.

Jim knew that the continental conquest model was dead long before discussions about selling off Wild Goose even started. When he came to Flying Dog, he got to help implement a craft beer policy that emphasized quality but was built on art and enticement. At FoDo, he got to try a different approach wherein he was taking former "national" brands and making them local. It was a novel challenge and one he relished. It was by this first approach, becoming a local beer rather than a national one, that gave the Dominion brand, which had been lagging behind the Fordham brand, not only a new life but also the chance to completely reinvent itself. The beer was superb and would remain the same, but a complete rebranding clearly would do more good than harm.

We'll cover the twenty-first-century beer garden in the fifth chapter, but for now, suffice it to say that FoDo had success at bringing in people to enjoy the craft beer lifestyle on premise. The Fordham and Dominion brewing property is in an industrial park, just off Route 1 in Dover, between

the International Speedway and Dover Air Force Base. One day, it had a number of pilots on the property knocking around on the three-hole golf course, drinking beers and chatting idly.

The self-confidence that borders on arrogance for which fliers are stereotypically known is rooted in their ancestral ties. Like other members of the armed services, they not only honor but also stand a little bit in awe of the generations of service people who preceded them. Sessionable beers aside, if anyone has enough to drink they wax philosophical and partially nostalgic. And so it was one day when a group of pilots spent the day off hanging around with Jim and his crew and talking beer and beer designs. "You know what you need to do?" one of them asked rhetorically. "You need to do some nose art."

Here follows a little history. Beer sometimes is sold in 750ml bottles called "bombers." In World War II, bombers were airplanes that delivered bombs. They often were adorned with pinups for luck and motivation. Dominion, a beer type without particularly interesting branding, had a very solid Double IPA (DIPA) that was in the midst of a crisis. Jim knew that the beer was good, but the labels weren't enticing and the sales were disproportionally low when compared with the quality. The suggestion about nose art was like a lightning strike. The new beer would be called Double D IPA and would feature a busty pinup à la World War II nose art.

Within six months, the brand was almost completely revived. In the new world of craft beer, where breaking in meant getting attention, one of the oldest (and most neglected) beers would get a new shot at a new market through rebranding. Double D IPA gained plenty of interest in the local liquor stores because the label stood out. People continued to buy it because the beer in the bottle with the cool art was really, really good. The gloves came off. Dominion would be the "Pinup" beer. All the beers would, one at a time, undergo a rebranding that took the style of beer, paired it with a better name when necessary and designed a pinup label for it.

Fordham underwent a different but similar redesign. For Jim, even though he had hoped it would happen, it was kind of an astounding learning experience. When he was at Flying Dog, he came to understand the power of labels, but he didn't really appreciate it until the FoDo turnaround. He was from a culture where making great beer was enough, and he had plenty of confidence in his beer. But the evidence was undeniable. Sometimes people had to be convinced to try new beers without knowing how they were going to taste. If you're making good beer, though, it doesn't matter so long as people find out about it. New drinkers discover Dominion beers because

Mispillion River Brewing opened selling mostly sixtels but eventually expanded to canning.

The tasting room at the Dogfish Head Brewery in Milton features nearly every brand that the brewery is producing for distribution. Each has its own "Off-Centered" tap handle.

Since the beers on tap rotate so often at craft breweries in general, and in Dogfish Head's Milton Brewery in particular, it is easiest to keep track on blackboards.

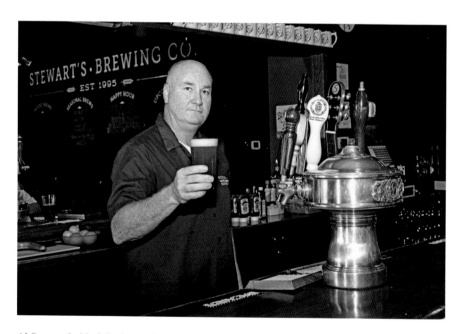

Al Stewart behind the bar at Stewart's Brewing Company in Bear. Al's was among the first craft brew pubs in the state, opening in 1995.

Megan Williams poses with one of the carts full of spent grain that Mispillion River Brewing will have picked up by a local farmer, who will feed it to his bison. The burgers are sold at one of the local restaurants.

The Iron Hill Brewery brewpub in Wilmington set the standard for the company's design, as it became an iconic part of the redeveloped Wilmington riverwalk.

Fordham and Dominion kegs ready to go at the Dover brewery. Using the mindset of "a mile deep and an inch wide," Jim Lutz, who runs the brewery, has reestablished the two beers in the region.

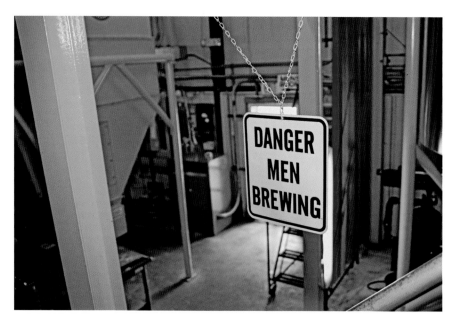

As a little nod to the experimental aspect of brewing in Delaware, signs like this are common in breweries.

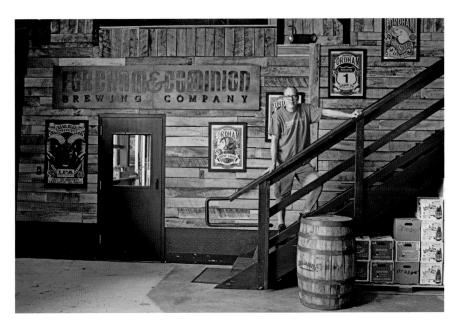

Jim Lutz, president of Fordham and Dominion Brewing in Dover, is one of the elder statesmen of craft beer, coming east from Colorado to work with Wild Goose in the 1980s. Jim has worked in the industry for more than forty years.

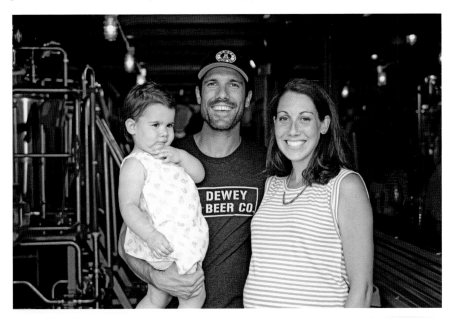

Brandon Smith and his family (wife Holly and daughter Meryl) have thrown themselves full bore into the craft beer business as part of the partnership that opened the Dewey Beer Company.

Hop plants are often part of the landscaping of any brewery. Although more for show than for use, it is a reminder about how important the local beer industry can be.

The canning line is being resurrected at Twin Lakes Brewing Company after the company moved from Greenville to Newport to accommodate growing demand for canned craft beer.

Matt Day, John Wick and Burke Morrison mug in their new brewery as they wait to resume operations. Day and Wick bought out co-founder Sam Hobbs and are growing the company in the new Newport brewery.

Fordham and Dominion director of marketing Ryan Telle behind the bar in the tasting room. Telle has been part of the team that redesigned the brand's look to entice people to try the beers. The beer hasn't changed, but it has gained more adherents based on the renewed marketing push and the beer's consistent quality.

Mary and Shawn Hager have been fans of 3rd Wave Brewing since it first opened and can be found there most Friday nights. The brewery's community-friendly attitude has earned it many diehard regulars.

Brewer Michael Riley from the Dewey Beer Company cleans up after a long morning of brewing. Riley was a full-time brewer and a full-time teacher when the brewery first opened, which kept him pretty busy.

Nearly every brewery in the state is dog friendly. At Dogfish Head's Milton location, they even are encouraged to shop.

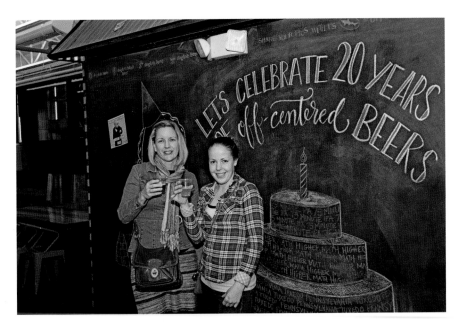

Susan Kehoe and Alex Colevas are avid craft beer fans and, living at the beach, particularly Dogfish Head fans. They were among the thousands who visited the brewery to help it celebrate its twentieth year of operations this year.

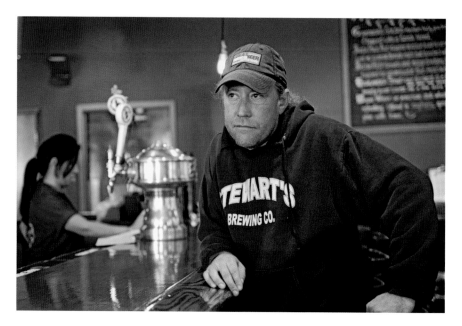

Ric Hoffman, head brewer at Stewart's Brewing Company, walked in off the street in 1998 looking for work. After rising very quickly to head brewer, he made his career by keeping people traveling to Stewart's for the beer.

Lori Clough, one of the owners of 3rd Wave Brewing in Delmar, is as happy behind the bar sharing her beer as she is anywhere else.

These friends are among the Dogfish Head regulars in the Milton brewery. The facility has several long wooden tables that are reminiscent of German beer halls but also are distinctly Dogfish.

Homebrew enthusiasts like Edd and Michelle Draper are a significant part of the craft beer revolution. They are regulars at 3rd Wave and Dogfish Head but make craft beer a central part of their weekend excursion when they're not brewing their own beer.

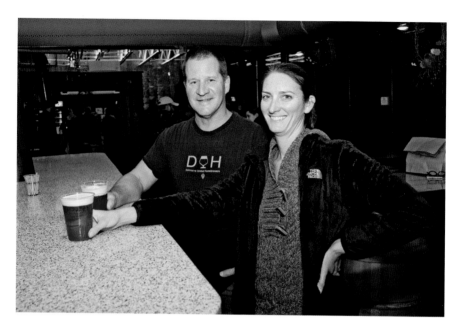

Alan Pongratz and Jennifer Luoma are members of Delmarva United Homebrewers (DUH) and have been a big part of the craft beer culture in the region for decades, both for their brewing and drinking.

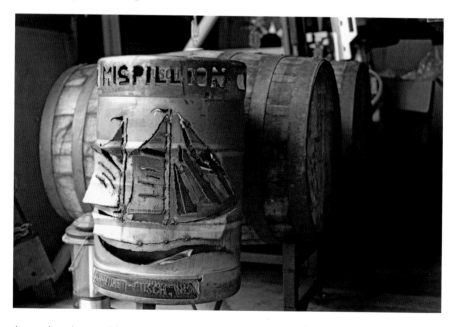

Atmosphere is everything at breweries like Mispillion, as they are destinations in a different way from the brewpubs. People come there to hang out more than to have a meal, so fires and parties always have an extra something to make them distinctive.

Ric Hoffman, brewer at Stewart's Brewing Company, checks the Peter Austin brewing system as he prepares to finish his day. The system was imported from England and was stuck in customs for six months, forcing Stewart's to open serving craft beer that was made elsewhere.

Eric and Megan Williams and brewer Ryan Maloney of Mispillion River Brewing Company mug during a photo shoot. Brewers only take themselves seriously when they're brewing.

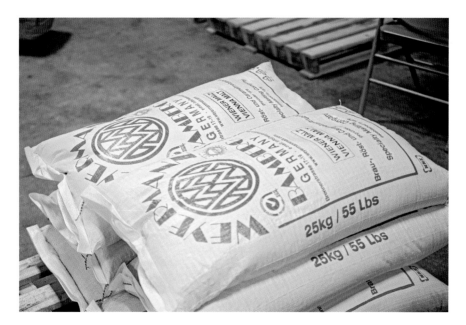

Specialty grains are where bold beers begin. Each brewery works to get the different malts it needs to make the beers it wants to make.

Stewart's Brewing Company has a warm pub feel accented by brass tap holders behind the bar.

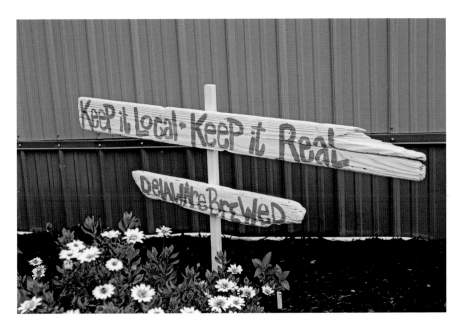

This sign just off the walkway at 16 Mile Brewery is part of the modern beer garden attitude prevalent at many of the production breweries. Promoting drinking local is good for all small craft breweries.

Blue Earl was hung up in name limbo for a while, but once it got the logos cleared and trademarked, it went big, adding tanks and widening the beer's distribution at the end of 2015.

Blue Earl owner Ronnie Price loves his work. Here he fills some growlers to take to a local radio station as part of a craft beer promotion.

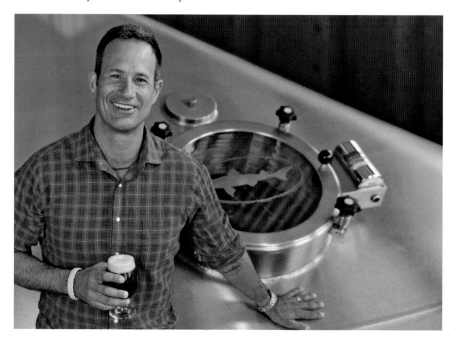

Sam Calagione, founder of Dogfish Head, was one of the most critical proponents of craft brewing in Delaware. He worked with state legislators to clear the way for brewing and distilling in the state.

Sean Lutz-Swank moves grain in the Fordham Dominion Brewery. Fordham and Dominion relocated to Dover from Maryland and Virginia, respectively, to form one company.

On the strength, in part, of the pinup labels, the Dominion brand grew substantially after 2012 to become a major force for local beer. Although it is proud of the success it had in attracting new drinkers with better labels and marketing, keeping customers with good beer is the only thing that sets craft beer apart.

of the pinups every day, which is an odd reversal from the way things were back in the 1980s.

The success of Dominion went on to influence Fordham in the label and naming convention department and has kick-started a rebranding on the Fordham side as well. But what is truly fascinating is that even though the labels have changed and are changing, the beers have remained the same. As odd as it seems, it's something Jim has learned to live with. When he started, his job was to convince people that craft beer was better based on the beer's quality. Now much of his job is to convince people that FoDo is better, but his primary enticement, beyond the relationship people develop when they come to the brewery, is the label.

Garageband Symphony

Between 2009 and 2015, Delaware beer grew significantly on the backs of homebrewers turning pro. There were two very, very important reasons for this. The first was that the economy tanked, specifically in the housing market. As a result of the housing crisis and ensuing financial downturn, there were a number of skilled people out of work. People who were in construction and manufacturing found their jobs either in jeopardy or gone altogether. This increased insecurity was the motivation that many needed to finally make the jump into entrepreneurship. Even though unemployment isn't, strictly speaking, the story for the crop of Delaware breweries that opened during this period, the dissatisfaction with the potential for job insecurity was definitely a factor that gave many of the brewers that extra incentive to try something they always had wanted to try.

The other factor that was critical was that the price of land plummeted. Land that people owned wasn't worth what it had been, and industrial buildings were empty and relatively inexpensive. These two factors helped spur the move from brewpubs to production breweries among the Delaware breweries and sparked the rise of the destination brewery. Dogfish Head, Stewart's Brewing Company and Iron Hill were restaurants with great beer. The rise of the destination brewery was under a different flag and attitude entirely.

SIXTEEN MILES FROM ANYWHERE

Although Fordham and Dominion was technically the first production-only brewery to open in the state, the opening was the result of prevailing economic pressures on the owners of existing breweries in other states. 16 Mile Brewery, the first production brewery opened solely for that purpose in Delaware, was opened in Georgetown by two homebrewing friends who took advantage of a new attitude toward craft beer that emerged as the first decade of the twenty-first century came to a close.

Chad Campbell and Brett McCrea opened 16 Mile Brewery in 2009 on property that had been in Brett's family. The original brewery was established in a converted barn and filled almost immediately with brewing equipment. The original commitment to growth is what set 16 Mile apart from the beginning. While many of the breweries in the region were content to start small and grow from there, 16 Mile went big from the start.

The brewery's name came from the town's designation as being sixteen miles from anywhere—meaning anywhere relevant to the post-colonial operations of Sussex County, Delaware. It was sixteen miles or less to the ocean or the state and county lines and the political center of one of the three Delaware counties. The brewery was an early adopter in the aluminum bottle craze, but before too long, the number of beers it wanted to make for distribution exceeded the number of bottles it could reasonably store. Unlike regular bottles, which could be relabeled, the twenty-two-ounce aluminum bottles had to be purchased preprinted and by the thousands, making them difficult to store before filling. Additionally, the bottles mostly were embraced by big beer companies for ballpark sales.

The brewery's biggest successes came in getting out as one of the first local beers in the region that was available in bottles, besides Dogfish Head. Delaware, for the most part, remained a brewpub state, so being out in front of the craft beer distribution curve was an important coup for 16 Mile. There was another Delaware brewery that was distributing at the time, but as 16 Mile geared up, that brewery was getting ready to move to another state.

Evolution Craft Brewery opened in Delmar, Delaware, a full four blocks from the Maryland line after the founders were unable to strike a deal with Maryland authorities. Brothers and restaurateurs John and Tom Knorr had planned to open a brewpub on the Delaware model on Maryland's Eastern Shore in Salisbury but had run into water use issues that couldn't be overcome before they needed to start brewing or give up altogether. The pair

16 Mile Brewing Company started out as a small operation with just a small tasting room in the section of the building on the right of the photo. Since then, it added the entire left-hand side, with the peak, and has become a massive influence on small business in the area.

bought an abandoned grocery store in the Salisbury suburb across the state line and had brewed beer to great acclaim and more than a little success. As much as the Knorrs loved making craft beer, their primary skill was in the restaurant business, and within two years, they were under pressure to both move and grow. They solved the water use issue by purchasing a recently closed ice plant and moved back across state lines into Salisbury.

THE EVOLUTION OF DELMAR BEER

By 2012, when Evolution Craft Brewery finally moved out of Delaware and into Maryland, the town it left was if not culturally devastated certainly off kilter, as if the wind had been knocked out of it. There had never been a real hope that Evolution Craft Brewery would transform Delmar into a beer destination the way that Dogfish Head had transformed the toney Rehoboth. But the brewery had been something of a source of town pride, and that pride was mildly on the wane.

It is difficult to overstate the effect that Evolution had had on Delmar. Unlike the other Delaware towns that had attracted craft breweries, Delmar had been an odd, incongruous choice. The town didn't have any restaurants worth mentioning and no entertainment beyond the Friday night high school football games and the dirt track. Unlike every other town in Delaware including Georgetown, Delmar wasn't missing a craft brewery as part of a bigger puzzle. There wasn't a puzzle or a plan; it was a town that had been constructed just before the Great Depression, begun as a suburb of Salisbury and in support of the railroad. In the last part of the twentieth century, the railroad was only barely needed to transport grain from one part of the peninsula to the other, so Delmar had been relegated to a place to live that was defined only by the fact that it wasn't in Salisbury.

Evolution had changed that almost immediately, providing the town with a different arc and an alternative narrative. Delmar was a town with a craft brewery in a world where that still was a rarity, and people there learned to drink craft beer. There were 1,653 breweries in America in 2009, but by the end of 2015, there was something closer to 4,500. Evolution's entire game plan had been to brew beer to supply the Knorr brothers' various restaurants in Maryland. It was established almost exclusively for that, but the beer's popularity caught fire as the demand for craft beer exploded. The company had drawn up plans to expand its Delmar plant to accommodate its anticipated growth and demand.

Although it had the town's blessing and complete approval, two events made the move necessary. The first was the discovery of several old Prohibition laws that prevented breweries from selling beer to themselves across state lines and limited the number of restaurants a single brewer could own. Fixing it would require rewriting legislation in at least one state but possibly two. It was something the company considered, but then the ice plant became available, which provided a perfect place for the massive brewery it would need to keep up with demand, as well as a cool opportunity for a new restaurant (the Evolution Public House).

When the Knorrs left, they didn't take the brewery with them. Their new place and new production goals would significantly outpace what could be done with the fifteen-barrel system they had been using. It was pretty much understood that Evolution would be replaced in short order, but there was still the remaining specter of the craft beer boom and bust. There was a general concern among the growing craft beer community that Evolution, an objectively good beer with a particularly artisan attitude, would be replaced by an inferior brewery. Among the homebrew community, there was a scramble to see who was ready to be the next to go pro.

WHAT'S IN A NAME?

Lori Clough and Suellen Vickers were regulars at Doug Griffith's homebrew store, where Lori originally had learned to brew. It recently had been rechristened Xtreme Brewing in honor of Sam Calagione's "how to" book of the same name, which Doug had contributed recipes to and had helped edit. There weren't a lot of female homebrewers, but neither were Lori and Suellen anomalies. Homebrewing appeals to problem solvers. Lori was the more enthusiastic of the two when it came to brewing, but Suellen was bigger on the sharing. Both were working solid jobs, Lori as a UPS driver and Suellen an orthodontist, and both were happy in their careers and in homebrewing. But the Evolution opportunity was too big, from Suellen's point of view, to pass up. Lori wasn't difficult to convince, but the two understood that the difference between making a good investment in brewing and a bad investment in brewing had to do with more than luck. Making certain that the right pieces are in place and functioning is critical—as is not leaping in feet first. Nearly one thousand more breweries had opened in the country during the three years between when Evolution opened in the building and Lori and Suellen planned their grand opening. In the intervening years, the bar to entry had gotten a little bit higher for several reasons. Among the most salient was the rise of the educated beer drinker, which is tied pretty closely to the rise of the homebrew culture.

This last point is something worth revisiting: homebrewers like to share. Imagine if your hobby was baking bread and you loved to try different combinations and styles, but you only could bake twenty loaves at a time. You would be making more bread than you ever could eat. Sharing it makes sense as much because you want the feedback as because it is an utterly wasteful production otherwise. For the prolific homebrewer, this is precisely the case. Sharing beer is as fun as getting feedback, but sharing is also necessary for the practical reasons of space and consumption.

An unintended aspect of sharing beers is that homebrewers get to teach one another about beers. They become comfortable bringing friends into the craft beer fold and get a sense about how to describe not just how a beer tastes but also why it tastes that way. Throughout the first decade of the twentieth century, the homebrewing culture boomed as much as did the craft beer culture. A lot of this is attributable to the ease of communication that was tied in with the rise of the Internet. By 2005, sharing niche hobbies like homebrewing was easier by far than it had been a decade before. Gear and ingredients could be purchased, but more importantly, ideas, tips and

Lori Clough was the first female brewer to open her own place, along with Suellen Vickers, by purchasing the Delmar building and equipment that Evolution Craft Brewery left behind when it moved. Although she doesn't get to brew as often as she would like, she still gets behind the bar regularly.

tricks could be shared. People could learn whatever they wanted to about beer. By the time the second craft beer revolution hit Delaware in 2010, which is when the established breweries began growing or eyeing growth, it thrived because of the rise of a more educated consumer who had access personally as well as online to beer standards in a way that never had been available before. The rise of the beer geek and critic wasn't lost on Lori, who took the lead in the brewing department.

Many if not most accomplished homebrewers have labels and merch made with their home brewery name on it. It is something they become attached to and is, in a way, part of the fun of sharing the beer. Long before they even considered going into business together, they had dubbed their home brewery 3rd Wave. The name references the surfing observation that the third wave is the best one, as waves tend to hit the beach in threes. Both women were avid if not accomplished surfers. Lori joked that she enjoys it, but it is as much an excuse to get out to the beach as it is a hobby. In fact, today her board hangs over the entrance to the brewhouse from the taproom.

A critical mistake that many of the new brewers were making at the time was not hiring a professional. The difficulties that come with running a professional

brewery are unimaginable for someone who isn't in it already. More than a few breweries that opened during this period suffered blows to their reputations because they started without a professional brewer and had to re-win the confidence of the newly educated consumers. To that end, Lori and Suellen built the cost of hiring a professional into their business plan as they worked toward opening 3rd Wave Brewing Company for real in Delmar.

Rare Birds

Breweries owned by women were still a relative rarity as 3rd Wave began its operations. Notably, Kim Jordan had started New Belgium brewing with her husband and grew it into the monster of craft beer that it since had become, but beyond that, beer wasn't particularly understood to be a woman's enterprise. Because of Delaware's relative size, when 3rd Wave opened, it was often joked that nearly 20 percent of the state's breweries were owned by women. What was even rarer, though, was their plan for production and growth. Although they got up and running relatively quickly after deciding to purchase the brewery, the brand was positioned for very slow growth by craft beer standards. It was critical to both owners that the beer be good first and popular second. The decision to hire John Panasiewicz to be the head brewer was part of that. John was part of the new school of brewing, and he worked his way up through the ranks at Iron Hill. He was young and enthusiastic and fit in with the 3rd Wave culture pretty easily. He and Lori got to work designing the beers that would be used for their debut. Early on, they had some difficulties working the kinks out of the system. No matter how skilled the brewer, there always is an adjustment period as they learn the ins and outs of whatever the new brewing system is. Just as with Al on the Peter Austin system, the instruments needed tuning.

This particular system was a workhorse. It had helped Evolution to grow into a great brewery in a relatively short period of time. Before that, it was one of the early brewhouses at Bell's brewery in Philadelphia. Interestingly, but not terribly surprisingly, one of John's former colleagues at Iron Hill had come to that brewery from Bell's. During this transitional period, as breweries opened at a rate that nearly outpaced the number of qualified brewers, it wasn't uncommon for any new brewery to take a little while to find its feet. Having John helped 3rd Wave negotiate the early learning curve pretty efficiently.

Delaware governor Jack Markell (center) visited the 3rd Wave in 2015 as part of a tour touting the ways that craft beer could improve the local economies. Markell and the rest of the Delaware legislators continue to support the craft brewing community both legislatively and through publicity and tourism sponsorships.

As with Evolution before it and 16 Mile, 3rd Wave wasn't a brewpub but rather just a production brewery, an increasingly common move in the area. Another part of the Dogfish Head legislation had made room for what we'll call taprooms, tasting areas in breweries where pints could be sold. The ability to sell pints was among the greatest benefits to craft beer in Delaware and nationwide as well. Of course, being able to offer tastings is an important aspect of the beer's eventual distribution, but selling pints is different because it makes the breweries more liquid faster. Without the ability to sell pints, the only way for breweries to get solvent is to get their beer to market as quickly as possible.

This wasn't a problem for Fordham and Dominion, since those beers already were established and distributed when they began production in Dover. Similarly, immediate sales were part of 16 Mile Brewery's business plan. For 3rd Wave, though, the ability to generate revenue without having beers in bottles or having to go right out and secure taps at local bars gave it time to come into its own. Once it did, the demand for craft beer was at a peak, and it had no trouble selling as much as it could make. As it turned out, it could make a lot.

But what 3rd Wave understood, and what many of the brewers would come to understand or to learn, was that for a production brewery and taproom, being there wasn't enough. Destination breweries would begin succeeding once they established themselves as places worth going for more than just a great pint.

GOOD PROVIDENCE

It wasn't a foregone conclusion that Eric Williams would found Mispillion River Brewing, but in retrospect, it kind of looks that way. His wife, Megan Williams (née McNamara), had come from a homebrewing family. Her father, Ed McNamara, had been an avid homebrewer. As a girl, Megan would catch fireflies and imprison them in glass carboys (the five-gallon containers used to ferment homebrew). Ed stored his finished beer in soda bottles and had collected a lot of gear over the years. He made even more.

Eric wasn't initially driven to become a homebrewer, but eventually his father-in-law's gear was moved into storage at the Williams house; Eric started tinkering with brewing beer. The tinkering became something of an obsession and then a mission. Building things and solving brewing problems occupied his entire weekends. Eventually, Eric joined the Delmarva United Homebrew club and began attending meetings. DUH was founded by Sam Calagione and Doug Griffith back in the mid-'90s. The group met at Dogfish Head in Rehoboth during the off season and at members' homes during the summer. By the time Eric joined, the club was established, and he was happy to find so many people as passionate about homebrewing as he. Among them was Ryan Maloney.

Ryan was younger than Eric but a more accomplished brewer, or at least a more experienced one. He worked for the state government in various capacities and spent his off time, as did Eric, brewing, hunting and fishing. The two hit it off immediately and started brewing together. As the craft beer culture heated up, there was a lot more demand for craft beers. Sussex County had three breweries already open: Dogfish Head, which by then had opened a major production facility in Milton; 16 Mile; and 3rd Wave. New Castle County had the brewpubs by Al Stewart and Iron Hill, with several more slated to open, but Kent County didn't have any breweries at all. Both men lived in Milford, which at the time was a town of roughly ten thousand people almost smack dead in the middle of the state.

When he's not brewing beer or cleaning the tanks, Ryan drives the forklift. Mispillion Brewing partners with local farmers, as do many of the craft brewers in Delaware, to dispose of the spent grain that makes up the better part of waste from brewing. Farmers usually trade for the grain, which they either feed their livestock or use for compost.

Eric was making a good living in what he called corporate America, working for a national chain. Megan Williams also earned a fair wage as a nurse, and they were happy with where they were in their lives. But there was something to be said for shaking things up, and time wasn't completely on their side. Brewing is a young (or at least younger) person's game. It takes an incredible amount of energy to brew, and the hours can be brutal. Plus, Milford was ripe for the introduction of a brewery.

For tax purposes as much as for the low cost of living, Delaware has been increasingly attractive to retirees from the northeast corridor and Pennsylvania. Drawn by inexpensive land, people on pensions were, for the first part of the twenty-first century, retiring to rural Delaware in droves. Central Delaware, particularly places along Route 1 and Route 13 in the middle ground of Sussex and Kent Counties, was particularly attractive to these retirees. Towns like Millsboro and Milford offered access to the coast without the beach house costs or expenses.

With the influx of people came a number of opportunities, and this area of the state experienced an amount of growth that included the addition of

restaurants and the redevelopment of downtowns to include art galleries and higher-end antique shops. Not too long before Eric and Ryan started talking about opening up a brewery, serial restaurateur Kevin Reading opened Abbott's Grill in Milford. Abbott's was among the new spate of restaurants that opened in the region focusing on locally sourced and calendar-correct meals as much as was reasonable. It had an in-depth craft beer menu and attracted the kind of clientele who expected as much.

"I'M ALMOST HAPPY WHEN SOMETHING BREAKS"

Based on the growth in the area, the availability of space and the desire to do something while they still were young enough, Eric and Megan decided that they were going to open a production brewery in an industrial park just outside Milford proper. The attraction of the industrial park for breweries is a simple calculation and one that appeals to brewers who are interested in being able to grow: logistics.

Industrial parks provide the things that a production brewery most needs: truck access, high ceilings, strong cement floors to support the heavy brewing equipment and few if any neighbors. The building that would become Mispillion River Brewing company had formerly been occupied by a blacksmith's shop. It already had a natural gas hookup and solar panels, which were appealing because breweries require a lot of heat and electricity. The team went to work making the place its own while it secured the funding to get underway. Eric said that there was a little temptation to have the brewery in Milford's downtown, but the cost to get a building there into the kind of shape that it would take to begin brewing was prohibitive.

Even though Eric and Ryan were both skilled homebrewers, Eric decided to bring on Jared Barnes, an experienced professional brewer who had worked at bigger breweries, to help get them started. Ryan consented to come aboard as assistant brewer, and things at Mispillion were underway.

From the time they were homebrewing together, the pair really enjoyed solving problems and repairing gear. It was more than the challenge of solving problems for as little money as possible. For brewers, especially when they're starting out, dealing with the concrete is one way of taking the edge off the less tangible problems like whether they would be able to attract people out to the middle of an industrial park to drink beer. By the time

From the very beginning, Mispillion River Brewing cultivated a following based on variety as much as quality. It always has at least a dozen beers on tap and uses colorful tap handles and beer names to add a little kitsch to the ordering process.

Mispillion River Brewing was preparing to open, that they would sell pints was a foregone conclusion.

There was a time when people considered opening purely production breweries. In fact, it often seems as if the idea that a brewery can be successful by just selling kegs to restaurants persists for at least the first part of the opening process. Some breweries in the region still attempt it, but the fact is that the markup on a pint sold over the bar is where the real profits are for a small craft brewery. If a brewery is going to have liquidity in the beginning, when it is the most necessary, what better way than to sell a five- or six-dollar pint that will go for seven dollars or more at any area restaurant?

Mispillion early on had set its sights on canning, something that had yet to catch on in lower Delaware, but it needed to make certain that its recipes were firing on all cylinders and that its beer was completely consistent. Although canning is increasingly popular among craft beer drinkers, cans still have a bad reputation among the casual drinker because there was a time when the metal flavor pervaded the beer itself. This hasn't happened in decades. Cans are widely understood to be better for craft beer because they are more light and air resistant even than bottles. The only problem with going directly to

cans was that the people buying craft beer in a can tended to be among the more savvy drinkers. Selling beer to them meant bringing an "A" game right from the first because with so many choices, a craft beer drinker isn't likely to give a brand a second chance if he or she is disappointed in any beer at any time. There are just too many other choices. This fact wasn't lost on the guys at Mispillion, and they spent a long time before they were ready to come out with their first can.

First One In, Last One Out

Twin Lakes brewery, which was operated out of what amounted to a barn in Greenville, Delaware, started brewing beer in 2006. It took five years for it to begin canning, but when it did, its Greenville Pale Ale was a hit all over the region. Founded by Jack Wick, Matt Day and Sam Hobbs and run by head brewer Rob Pfeiffer, Twin Lakes grew quickly. As demand for its beer skyrocketed, there was some disagreement about whether to continue growing and, if so, how fast. The company closed temporarily in the summer of 2015 and moved the canning facility to a Newport industrial park just a few miles away. The new building was still under construction in the fall of 2015, but remaining owners Wick and Day said that they still had big plans for the brewery.

Growth is always going to be a struggle for craft brewers because, unlike regular companies, they always will face questions about motivation and authenticity. Craft beer enthusiasts buy as much into a brewery's narrative as they do its beer. As Jim Lutz said upon taking over at Fordham and Old Dominion, local people want to have a relationship with the beer. Building on that, many craft beer drinkers want to know that the people who live near faraway craft breweries have a relationship with the brand. The real strength of the craft beer industry lies in the fact that these craft beer enthusiasts feel as if they have both an investment and some control over the industry. They want to help guard it against anyone who might mess it up.

Jack Wick was excited about the prospect of having a bigger tasting room with better, or at least easier, public access in the new place. They still were brewing beer and holding events as the year wore on and still had every intention of continuing the canning tradition that made the beer so big and famous that it nearly collapsed on itself. Dealing with the pressures of demand is easier when everyone is working from the same page. With a

During the interim period of the brewery's move from Greenville to Newton, Twin Lakes was still making all the beers that kept it popular; it just wasn't making enough to sustain its massive canning push. Its plan was to right itself as quickly as possible by reopening a new tasting room and canning facility.

As it prepares to expand, Blue Earl Brewing in Smyrna has more than doubled its capacity with the acquisition of these tanks. The brewer began bottling beer for distribution at the end of 2015, with an eye on major, rapid growth in 2016.

consolidated ownership, that is precisely the tack that the revamped Twin Lakes brewing set out to take.

Fans of the beer were disappointed because the change in ownership meant that Rob Pfeiffer, who was a longtime homebrew community leader, was no longer brewing professionally in the area. For better or worse, though, Rob wasn't unemployed for long.

It Is Business and Personal

Besides the pressures from the outside about authenticity and growth, there is an amount of infighting among brewers that is common to other businesses but often makes craft beer enthusiasts feel a little gross. Turf wars were inevitable, though, as craft beer became a legitimate industry. (As of 2016, it was projected that craft will soon make up 20 percent of the U.S. market before 2020.) For the new guys, who just want to make beer, this sometimes can be a stark reminder that the later you enter the game, the rougher everyone plays.

Ronnie Price was an avid homebrewer for more than twenty years before he made the leap from homebrewer to pro brewer, or at least started to. In 2012, with the encouragement of many of his friends and his wife, Rosemary, Ronnie got to work on his business plan, which called for a full production brewery in Smyrna. He started spending more and more time at Twin Lakes brewery in Greenville, which at the time was running a full brewing operation, including a tasting room and production brewery. His hope was that by volunteering there, he would get a sense of what it was like to work in a brewery that had to meet local as well as distribution demands. Ronnie expected to go big right from the start.

His business plan named the brewery Smokestack Brewing, but when he attempted to trademark it, word came back that it was too close to a Boulevard Brewing Company series of beers. As he continued to develop his beers, he tried to register Warlock Brewing Company. This one seemed to pass muster, and Ronnie and the rest of the people involved with the brewery began operating under that name. It would still be another year or more before the brewery was opened, but they designed a logo and bought gear that they wore to beer festivals and homebrew competitions where they were allowed to pour samples of their beer. But Warlock also turned out to be a problematic name.

As have many of the newest production breweries in Delaware, Blue Earl Brewing Company opened in an industrial park. It provides lots of easy access for trucks bringing in supplies and hauling away beer, as well as eases tensions between brewers and neighbors all over the state.

Although it wasn't a registered trademark, Warlock was the name of a beer made by Southern Tier, a storied and massive craft brewery in New York. As Ronnie got his financing together for the project and began planning, he decided that he wanted to fight for the name. The months wore on, and after spending a small fortune on lawyer fees and with his first brew day pending, he decided that it wasn't worth pouring any more money into the fight. The bigger brewery usually will win—it was just a tough introduction to the craft fraternity. Ronnie is a blues musician and had been for much of his adult life. His brother-in-law suggested that he just go with the name Blue Earl, which incorporated Ronnie's middle name and another of his passions. It stuck at once, and there were no objections from larger, better-funded breweries.

Even if he didn't win that battle, he did have a little bit of luck when it came to getting fully staffed. Ronnie knew Rob Pfeiffer from the First State homebrew club, which is the one that encompasses the northern part of Delaware and includes parts of Pennsylvania and New Jersey. He also knew that Rob was looking for work and was as skilled a brewer as he could hope to entice. Having a name local brewer was a huge boon, and Ronnie went for his permits, believing that it was all smooth sailing from there.

Elsewhere in Delaware, especially by 2014, towns were competing to have new craft breweries open up. Over the preceding ten or so years nationwide, craft breweries had established themselves as the kind of economic engine that every small town could use. Breweries employ enough people to be a productive small business, but not so many that if the brewery closes there will be mass unemployment. Craft breweries attract a different kind of patron from a regular bar—the kind who spends more money and is likely to patronize the restaurants and other downtown shops that have been part of every downtown revitalization project in the region.

Smyrna, however, was not elsewhere, and it wasn't interested in having another alcohol-producing entity in town. The Painted Stave was one of the area's first distilleries, and the town zoning committee said that one was enough. Ronnie went to the town council to see if the members would intervene on his behalf but was sent packing. For a while, it looked as if he was going to move the brewery to Middletown, the neighboring municipality, but eventually cooler heads prevailed. Members of the city administration encouraged Ronnie to go back to the mayor and council and make another appeal. When he did, the motion to allow Blue Earl to open and begin brewing passed unanimously.

English Beer in the German Tradition

A Tale of Two Cultures

Delaware beer can be divided pretty easily along a brewery/brewpub line. While the line isn't strict for our purposes, the difference will have to be food. Brewpubs have food menus and restaurant staffs; breweries do not. During the last part of the twentieth century, this wasn't an issue. People would come, have a tasting of beer, maybe get a growler filled and then head on to another place. Once the culture really started to catch on, though, there was a need by many patrons to treat destination breweries as just that: not just places to stop by but rather places to stop and stay. Once legislation was passed that allowed brewers to sell pints, breweries became even more popular among the homebrewers who longed to brew for a living but had no interest in getting into the restaurant business.

The production breweries highlighted in the fourth chapter fell into this category. There were people who knew that they could make a living selling good beer but who also needed to be able to sell pints as a way both of promoting their beer and keeping the cash flow flowing. To be successful just selling beer, however, the brewers had to come up with novel approaches. It is no good to expect people to just spend a day drinking beer as if they were a sot at an old man bar. Brewers provided incentives to stay but not incentives to get drunk and, in doing so, coincidentally built a culture that became strong enough to spur on an additional industry and build local

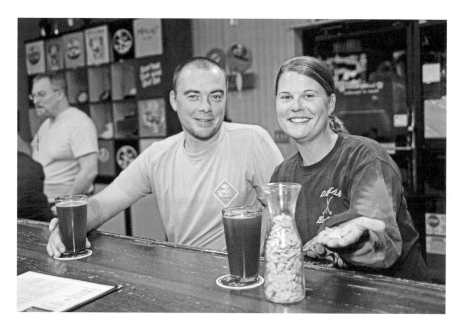

For couples like Doug Kemp and Angie Jackson, a night out at the brewery has become a legitimate way to spend an evening together. As regular patrons of 3rd Wave in Delmar, the pair gets a home-away-from-home experience with Goldfish.

economies even more. To do all of these things, they borrowed a page from the Germans.

The Biergarten grew out of the lagering tradition in eighteenth-century Bavaria. Breweries there set up tables and chairs and served the beer they had lagered away during the winter months all throughout the summer. As bigger breweries began providing open-air beer service for their patrons and serving food, it began to muscle out smaller breweries that didn't have the staff or the inclination to serve their own fare. The smaller breweries petitioned the king to ban what they saw as an unfair practice. Instead, a compromise was struck allowing breweries to serve bread alone but permitting people to bring their own food. Eventually, the prohibition on serving food fell away, and Biergarten breweries placed tablecloths on those tables where food was served from the brewer's kitchen and left bare tables where outside food was allowed.

Over the years, the traditions and practices associated with the Biergarten changed as Germans brought their practices with them, but the central aspect of what became the beer garden in America remained the same. There were communal tables, and fraternization was encouraged.

OF PUBS AND BREWERIES

The beer gardens of nineteenth-century Wilmington, for example, were likely as big a draw because of the chance to be social as for the beer served there. Women and children were allowed. Kids played and adults talked and drank. It was like a public park where they served beer. People could bring along picnic lunches or treat themselves to whatever bill of fare was presented. The beer garden that was associated with Joseph Stoeckle and Diamond State Brewing was several blocks from the brewery that supplied the beer. Patrons likely were encouraged to bring their own food and enjoy themselves. Although there is no evidence of it, it is fun to imagine that the German Hall was one place to get good beer throughout Prohibition

Especially as the waves of immigrants came in from Germany, the beer garden likely acted as a clearinghouse of information where new immigrants could come and, comfortable in the familiarity and the language, get acquainted with the neighbors. They could get leads on jobs or shelter or make connections with family members, even distant cousins, who might already have arrived.

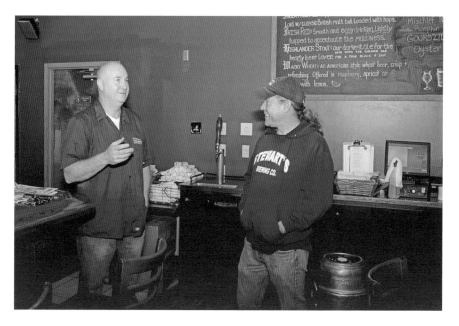

Al Stewart and head brewer Ric Hoffman consult between shifts. Rick tends to brew in the morning and prepare to leave as Al comes in for the evening shift. By staying in close contact with each other and the chef, Stewarts has the advantage of not having to worry about where to get good food to serve in its brewery.

The story of the invention of the beer garden isn't far off from the separation between the brewpubs and the production breweries that began opening in Delaware in the first decade of the twenty-first century. There was no question that the ability to serve pints was critical, especially for brewing startups, but finding a way to keep people drinking without the risk of overserving them was a challenge. Or it would have been if the brewers focused on that aspect of the business. Pubs had the distinct advantage of being able to serve food. But food meant more staff and planning than many of the brewers had signed on for or even desired.

Rather than agonize over how to get and keep people in the breweries, most of the brewers took a page from their homebrew books. Make people feel happy and welcome, and the rest will take care of itself. The most important part of that equation was establishing camaraderie between patrons and getting them to bond over beer. The most effective way to do that was the brewery tours.

Take a Look Around

When Jim Lutz came to Fordham and Dominion, he wanted to change the culture and establish FoDo as Dover's hometown brewery. Social media has been the brewer's best friend since 2005 or so, when it started being used widely. By the time Jim got to Dover in 2011, it already made more sense for a lot of small breweries to spend advertising money promoting themselves online than it did for them to undertake a print campaign. Getting people into the brewery for a tour wasn't just about selling that additional six-pack, though. As the numbers of people through the door increased, they got to see the tasting room. The room at FoDo is pretty small, set to hold fewer than a dozen people at a time. But when the weather is fine, outside visitors will find a fire pit in the center of a circular arrangement of railroad ties. People are encouraged to come back and sit and enjoy the evening at the brewery.

Tours always were important parts of Dogfish Head even before the massive Milton production brewery opened, but once it did, they became central selling points. It wasn't just about getting people to buy the beer; it was about helping them develop the language for discussing beer with other people. The Dogfish Head tour takes the better part of an hour and traverses the entire facility, explaining to attendees how the brewing process works from conception to quality control to bottling and shipping.

Even as canning grows in popularity, many of the Delaware breweries continue to bottle with increasing success. Bottles remain the preferred container for many craft beer people, although cans are attractive to those who are more active outdoors.

Tours of most breweries generally are free and often include tastings at the end. By arranging to give tours and tastings, brewers gave people a reason to come out to the brewery and get a better understanding of what went on there. Personalized tours make people a little more invested in the beers and, for better or worse, give people a sense of ownership. There is some cache among the craft beer enthusiasts when it comes to having had tours of a particular brewery. They like being able to share inside knowledge with people who are interested in hearing about the tours. They also like being that much closer to both the beers and the process.

The other important part of any of the brewery tours is the connection that people make with one another on the tour, and this is something that brewers find to be true at every turn when it comes to craft beer: people already are pretty much in the same frame of mind. People might go to bars or restaurants for different reasons, but when a person comes through the door into a craft brewery, it is a safe bet that they are interested in craft beer. There is always something to talk about and, because of the way the breweries are set up, always the opportunity to talk about the beers.

People who come from out of town use tastings and tours to get the lay of the land when it comes to other breweries in the area, often asking which breweries to make certain to visit if their trip is too short to hit them all.

'Cause They're So Delicious

While tours are a great introduction to the breweries, convincing people to spend the evening there had an evolution all its own. Before 3rd Wave Brewing opened, people were encouraged to take tours and fill growlers, even to have pints, but they weren't enticed. Evolution was about the beer more than about the culture. More than anything else, this likely had to do with the fact that the brewery was a startup that had been aimed at different things. The Knorrs chose Delmar because it was available and had the right amount of space. They provided picnic tables in the front, but beyond that, they didn't do a lot to encourage people to make an evening of their visit to the brewery.

When Lori Clough and Suellen Vickers took over the place, they were no more interested in serving food than had been the guys at Evolution. What they were interested in, though, was creating a culture. From the early days, as much as any other place, 3rd Wave was like a bar with no food, and that was something Lori in particular was sensitive about. She wanted people to be comfortable coming and staying and also not worry too much about the prospect of drinking on an empty stomach. It started with Pepperidge Farm Goldfish.

Lori wanted to have bar snacks but didn't want to put out bowls that multiple people would have to dip their hands into. She settled on Goldfish served from water carafes. The idea was that people could pour them into their hands but not reach down the tube after them. Goldfish were more expensive than, say, pretzels, but they also were more distinctive. Right from the time they opened, the Goldfish were a novelty that made 3rd Wave stand out as a destination for beer. And the Goldfish were just the start.

When the brewery belonged to Evolution, there were some picnic tables set outside for people who wanted to smoke. Lori and Suellen rearranged them and dressed up the front of the building with bushes and flower pots, the idea being to transform the place into an area where people want to come and sit on a pleasant evening or afternoon, rather than just leave it a glorified smoking section.

Besides offering Goldfish on the bar, 3rd Wave also bottles 750ml beers from its cask program that it sells as special releases quarterly. Although it also bottles and cans in the traditional manner, the specialty bottles make going there an occasion.

Lastly, people were encouraged to bring their own food or to order in. There was a pizza place around the corner, and more than occasionally, people would come through the doors holding a pizza and sit down to have a beer. Delmar has limited takeout options, but that didn't stop people from bringing their own food. As more people continued to come to the brewery prepared to spend some time, it started to morph into a kind of twenty-first-century beer garden. People brought their babies, people brought their dogs and people arranged to have birthday parties and political fundraisers at the brewery.

Delmar is something of a closed community, but Lori and Suellen took their places as business owners even though neither of them lived in town. Not only were they embraced by the town administration, which was happy to have a business that clearly was on the road to success, but they were also embraced by their regular customers.

Among them was Nick Schlegel, who approached Lori for permission to start a business of his own. Nick wanted to begin serving food outside in the parking lot. Lori was encouraging but also cautious. She told him that everything from permitting to securing legal and moral blessings from the town was his responsibility and he agreed.

BACKWARD INTO TAVERNS

Nick Schlegel started what would come to be "In Your Backyard BarBq" at a folding table that he set up roadside. Over the course of a year, based solely on sales to 3rd Wave patrons, Nick eventually got a proper food truck and set up in the parking lot three to four days per week. The food truck increased the amount of time that people stayed and the amount of beer they were comfortable drinking. It became the first symbiotic relationship between a brewery and a food truck in Delaware. It didn't take long to spread to other breweries. In fact, by the time the other production brewers started opening, part of the deal was to try and find a food truck to work with. Over in Milford, Eric Williams found several.

Mispillion River Brewing was designed under the expectation that there would be food trucks interested in serving the brewery's customers. Even as they were working on the building, Eric noticed the Mr. Barbecue food truck that found its way into the industrial park every day around noon. As the building neared completion, he added a concrete pad on the side of the building that would be used for a combination food truck/hangout area.

Blue Earl brewing still has plenty of room to grow, but it is taking the process slowly. Although it only opened in 2013, the brand has become very popular among the locals, who come out every weekend to enjoy the beers and see which of the food trucks have come out for the evening.

As late as 2010, people were saying that there was no demand for food trucks in rural Delaware, but by the time Mispillion River Brewing opened in 2013, it was able to engage a lineup of trucks; from barbecue to tacos to Thai food, food trucks have caught on in a big way in Delaware and particularly at Mispillion. Eric hadn't planned it that way, but he was happy to have requests from other food trucks not long after the brewery opened.

Food trucks go a long way toward making a destination brewery more of a destination. People can go on a Friday or Saturday and plan on spending the evening. It took a while for breweries to shake off the shackles of expectation when it came to the customer experience. They were so focused on making the beer experience exceptional that some obvious solutions had to be brought to them, which is a testament to some of the more creative businesses that have cropped up in the wake of the craft beer boom.

Dressing up the outside of the brewery was as critical for Mispillion River Brewing as for any of the other breweries, but Eric, Megan and Ryan had the benefit of seeing how things had been done elsewhere. This knowledge didn't push them to copy what was done elsewhere, but rather it informed their decisions as to how to make a first impression that was particularly Mispillion.

If there is a recurring theme that runs through every brewery in Delaware, it is this notion of wanting to do what they want to do. Certainly there is a culture of respecting the past and honoring the process, but since Delaware beer was built on the homebrew premise of being experimental, this doesn't get one very far when it comes to establishing general practices. A better anchor would be the notion of customer as guest. This is as true for the homebrewers as they share their beers as it is for the brewers who sell them. From this perspective, doing what you want to do is tempered by a will to be hospitable.

When it comes to beer and even to entertainment, the brewers can take a "spaghetti at the wall" approach, but when it comes to food trucks, there seems to be a different approach for many of them. Lori Clough at 3rd Wave, for example, is committed to Nick's In Your Backyard BarBq because he was first. In addition to an unspoken commitment to allowing him to remain, she was open with her suggestion for him not to be there every night during the week. Lori didn't want him to feel as if he was working for her and tried to make that as clear as possible. After all, he went out on a limb and started a business with her as his sole customer.

In Milford, the opposite was true. Mr. Barbecue was one of several active food trucks. As a result, the brewery works with them all to make out a

The guys at Mispillion River Brewing are among those who have embraced canning in a big way. It helps them to get more shelf space across the entire region because of the demand for craft beer in cans.

rotation that is fair for the trucks and the brewery and also interesting for the customers. It works out. Trucks that are more popular get more spots, and whichever truck is going to be there is known to the customers. If a truck becomes so unpopular that no one is making a living, they all can part ways with no hard feelings. There is no sign of that happening any time soon, which returns us to the brewery's layout as it relates to hospitality.

Because it is far from the center of town and in an industrial park, Mispillion River Brewing can have a massive fire pit. It is, in itself, an attraction that brings people in and remains a reflection of both Eric's and Ryan Maloney's homebrew roots.

Take a look at any of the independent craft brewery layouts and you will see precisely how the owners would have set it up in their own backyards. Even Dogfish Head, with its famous Steam Punk Treehouse and its steel and glass, has a few bocce courts for people to play on as they wait for their tours or just enjoy their beers.

In the end, that is the primary way these modern-day beer gardens are established, with an eye on building community every night, no matter who shows up. Sure, more people are likely to show up on a Saturday night than,

say, on a Tuesday at lunchtime. But the breweries all are set up in such a way that whenever you show up, there is an equal distribution of things to do or beers to drink, given the likely number of people expected.

Ways and Means

In some cases, food trucks actually have become a little recursive. Outside the Dogfish Head brewery in Milton, for example, you can find the Dogfish Head food truck. Similarly, Sobo's, one of the restaurants started by the Knorr brothers, also has begun bringing food trucks to different events. And it is the events that have made both the food trucks and the various tourism departments around the area happy.

When 16 Mile Brewing renovated in 2012, the culture as well as the building changed significantly. Chad Campbell and Brett McCrea had invested in more than just a tasting room; they jump-started a new way of doing things in Georgetown that focused on the seventeenth-century model of the tavern as the center of town. Interestingly, Georgetown has a very distinctive town center that contains shops, restaurants and the county government but, for one reason or another, doesn't shout "community." The plan was to change that on the brewery property by engaging in the kind of partnerships that breweries had engaged in throughout history.

Breweries have always had, and continue to have, close ties with farmers. Making beer produces an obscene amount of spent grain. Brewers all over the peninsula have deals with farmers who come and haul it away to feed their livestock. Nearly every brewery has a deal with a farmer who provides some barter in return for the feed. For 16 Mile, the spent grain is used in town to make pretzels and bread at a local bakery.

As an aside, in 3rd Wave's first year, the farmer it was working with ended up giving it an obscene amount of watermelon. Stymied for what to do with so many melons, Lori and head brewer John Panasiewicz made a watermelon beer. It wasn't precisely what they had in mind when they made the barter, but the beer was popular enough. Dogfish Head and Mispillion River, among others, get bison meat out of their deals. The bison burgers sold at Abbott's Grill are from animals fed with Mispillion River Brewing's spent grain.

Using their connections to local artisans, 16 Mile started hosting a farmers' market on the property. From there, and by a natural extension, it started

16 Mile Brewery hand-packs the beer that it ships all over the region to liquor stores and bars, in addition to having expanded its tasting room. By making the property more welcoming, the brewery attracts people who come for other events and can take bottled beer home with them.

holding other events. Going to events—like beer festivals, for example—is a good way for breweries to get exposure to people who might not otherwise have heard of or tried their beer. Holding events, however, establishes a destination brewery that much closer to the center of town. It is a subtle way of reminding people that their local brewery is a place for community members to gather—a reminder that a good time can include beer without being about beer.

In Dover, Fordham and Dominion have a similar attitude. Although the brewery doesn't generally have entertainment, it has many specialty nights and hosts regular festivals where it invites community partners out to use the property as a staging ground for something wonderful. It all has to do with playing to your own strengths. For instance, Ronnie Price and the folks at Blue Earl established that brewery as a center for live music. It has been an important part of their approach.

INTRODUCING BEER GARDEN 2.0

Depending on where you find yourself on the Delmarva Peninsula, you have more or less access to culture. In Wilmington you can catch a road production, in Delmar you can catch a dirt track race and along the beach area you can, on any given weekend, attend an art show featuring middle-aged people who had always wanted to explore their inner artist. In a world and a region where culture is as culture does, however, there always is respite at the nearest brewery. There you can find a distillation of all the things that are valuable about a culture. They are there unvarnished and without the pretense of anything other than a true representation of the immediate area.

The rise of standalone breweries in the region brought with it an almost accidental cultural revolution where none could have occurred before. At the turn of the twentieth century, America saw the height of the beer garden. It was a place for immigrants to meet their fellows and feel comfortable in the knowledge that they weren't alone; they found a cache of people who understood the way they spoke and the way they behaved.

At the turn of the twenty-first century, beer gardens have changed to some extent but remain firmly rooted as a reflection of the culture immediately surrounding them. The new beer gardens are some of the final places where it is impossible, or nearly impossible, to have a private experience. They are among the last truly public spaces we enter for open social interaction. This is more by design than we might like to think.

Picture a tasting room. In it, people who did not come to the brewery together sit cheek and jowl evaluating the beer and the ambiance. Being at a brewery is one of the few live action review spaces that exists. We speak with strangers at a brewery more easily than at a bar because it is encouraged. No one is ever going to ask you what you think of the Maker's Mark you ordered. Similarly, in a restaurant no one would have the courage to walk up to your table and ask you how the steak is. But at a production brewery tasting room, this kind of behavior and this true, unvarnished interaction is not merely encouraged but also expected and welcomed.

Critically, not only is it one of the last places where strangers ask one another their opinions, a tasting room might also be the last place in America where strangers can respectfully disagree and give reasons. Think on that a second. Imagine being at a movie or concert and having someone ask you to critique the performance for them. Imagine responding and having a civil disagreement about the meat of the experience. It happens so rarely that "never" qualifies as a descriptor. Say a beer is "too hoppy" or "too malty"

aloud in any place that makes beer and you will make new friends, or at least associates based on the fact that they disagree.

Easily the happiest difference between beer gardens at the turn of the twentieth century and the turn of the twenty-first is the presence of dogs. Being child friendly has been an important aspect of running these modern-day beer gardens, but being dog friendly has been critical. People like bringing their dogs to the brewery, and especially in places without a restaurant, dogs are very welcome. In preparation for publishing this book, we traveled to all of the breweries and saw dogs at nearly every one. And it isn't so much about the dogs themselves so much as it is about the owners, who keep their dogs well under control both around people and other dogs. That the dogs tend to all be well behaved often is attributed to the fact that the owner is comfortable. If that is the case, there are a lot of comfortable pet owners enjoying beers at every brewery in the region.

WHY SO MANY BEERS?

One way to keep conversation lively is to make certain that there are plenty of beers for everyone to drink. Megan Williams spoke about this when she was discussing the prevailing attitude at Mispillion River Brewing. Having been raised in a homebrewing family, helping her father brew from an early age, she was sensitive to how aggressive craft beer can appear to the uninitiated. With all the talk about extreme brewing and all of the attempts to make the highest-alcohol beers, or the hoppiest or the one with the highest Scoville Scale rating, it is easy and tempting to preach mainly to the converted. Still, there is not one brewery that doesn't have at least one, but often more than one, gateway beer on tap. A gateway beer is one that is easily palatable. It is a beer that someone who isn't a craft beer enthusiast will appreciate so much that they are willing to make bolder decisions about craft beer in the future.

Dogfish Head and Stewart's Brewing Company each opened with just four beers on tap. As they grew, they set the standard for what people could expect from a craft brewery. At the top of the list, there always were two beers—one that was very accessible and one that was particularly challenging. This notion of always having something that is inoffensive to the most sensitive palate is at the root of the massive beer lists that breweries today seem to maintain. Blue Earl, which opened in the middle of 2015, did so with twelve beers

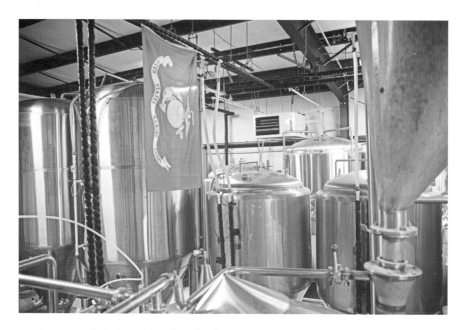

The brewery at Mispillion River Brewing Company is a full-time proposition, running two shifts on many days to keep up with increasing demand, as well as the principles' desire to maintain a diversity of beers in the taproom.

on tap. Similarly, 3rd Wave regularly maintains fourteen, including one experimental beer on tap at all times. This isn't an accident.

As the beer industry grows, the better brewers, the ones with track records for making good beers, become all the more valuable. They also are very aware that there is a creative danger in becoming, as Al Stewart says, "the guy who makes the donuts." Keeping brewers creative and happy is critical for breweries. This is because resting on your best beer is similar to betting that tastes never will change. It's a loser from the word go.

In 2015, Ryan Maloney took a big chance and made a chocolate stout he called Wonka Bar. It won a silver medal at the Great American Beer Festival. It was the only beer in the region to medal. The news came back to Mispillion River Brewing both as good and bad news. The good news was that it could hang another medal on the wall. The bad news was that Ryan would have to make a ton of Wonka Bar just to meet resurgent demand.

In an alternate universe where Mispillion River could, and wanted to, survive on the strength of Wonka Bar alone, Ryan wouldn't be long for this region. No matter how great a beer is, making it every day goes beyond tedium into soul crushing. This is why Dogfish Head makes 60 Minute IPA

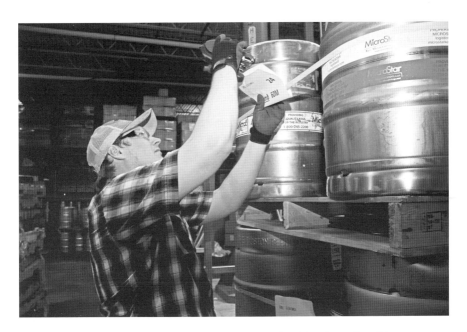

As opposed to the smaller breweries, Dogfish Head sends pallet after pallet of beer out every day to restaurants bars and liquor stores all over the country. It requires a well-coordinated effort, from the brewers to the packers.

less than half of the time it brews and why Ric Hoffman at Stewart's Brewing Company has lasted as head brewer for nearly two decades. Finding people who are great at what they do is difficult enough. Allowing them to be great takes a resolve that is beyond many people, especially those who succeed in a creative business.

We Make Beer Here

Living Taverns Down

Standalone breweries had to find their way through trial and error. Brewpubs had a completely different set of problems but also many advantages. From a business perspective, brewpubs have food, so they run at a higher cost. The cost isn't just about the food, though; it is about the people who serve it and cook it. Those people not only have to know a lot about the food, but they also have to know a lot about the beer and the way it goes best with the food.

Brewpubs are the modern-day descendants of taverns, but their chain was broken by changing expectations and the reinvention of the American restaurant. It is fascinating and amazing not only that they have come back, but also that they've come back in such a big way. It took a little distance and perspective.

Long before Prohibition nearly killed off the beer industry in America, taverns were on the wane after something of a heyday in the colonial and post-Revolutionary era. The fall of taverns had to do with the rise of the saloon and, to some extent, the women's movement that helped give Prohibition its steam.

Taverns were the centers of colonial life. They were the places where people could meet before the era of the government building. They acted as courthouses and hotels as well as as local bars. Often run by a couple, taverns mainly were places for men to come and get a meal if they were on the road or single. Until well after the American Revolution, taverns were making their own beer, wine and spirits, generally. Larger taverns in larger cities like

Wilmington and Dover would have the buying opportunity and power to supplement what they made with brands that could be bought elsewhere.

For his part, Joseph Stoeckle started brewing in a tavern and then a hotel before he purchased Diamond State Brewery. But the notion of the restaurant or the brewpub that we have now is more an invention of the twentieth century. Although the middle classes might go to beer gardens as families or couples, restaurants were restaurants and bars were bars as Prohibition began to heat up. Primarily this had to do with the ready availability of inexpensive beer, wine and liquor. The economy of scale at which the brewers and distillers were working meant that it was much cheaper for the restaurateurs of the day to buy their alcoholic beverages than it was for them to make them. Saloons and other places where beer was made might serve food, but they weren't restaurants and women weren't particularly allowed or welcome.

By the time the fight over Prohibition started, taverns that made their own beer already were practically dead in Delaware. As part of the movement to reduce what was seen as a brewery's hold over the market, and in deference to the appeasement practices of temperance, restaurants eventually were prohibited from making their own beer. In-house brewing then, as today, provides significant profit margins, allowing the brewpubs of the day to keep prices down in a world where driving prices up was a preferred method of reducing people's alcohol intake. There was also the opportunity for taverns to supply other restaurants as it got harder to procure inexpensive mass-produced beer.

As Sam Calagione and Al Stewart would discover later, there is a fantastic incentive to sell your beer, even when you mostly are making it for your own patrons. Although it is a smaller operation, by definition the economy of scale remains the same. If you are going to have brewing equipment on premises and pay a professional brewer to make beer, it only makes sense to sell your overage to other bars and restaurants.

RETURN OF THE BREWPUB

All throughout the craft beer boom in the 1980s, the disposition was to open standalone breweries that sold beer to bars and restaurants. The notion of a brewpub made sense but also was a little new to both restaurateurs and patrons. The Manhattan Brewing Company, which opened in New York in 1984, was one of the first brewpubs on the East Coast, but it had trouble staying open over the years.

The property that now houses the Dewey Beer Company is right in downtown Dewey Beach, which can be nearly empty for much of the year. It attracts people off season because it continues to brew as well as to serve food.

When Alan Pugsley opened his brewpub, Federal Jack's in Kennebunk, it was as an extension to Kennebunk Brewing, but it still is open today and still successful. Federal Jack's opened just a little more than a year before Dogfish Head Brewings and Eats and Stewart's Brewing Company opened in 1995. Since then, brewpubs have made a strong comeback. By 2015, when the first brewpubs in Delaware celebrated their twentieth anniversaries, there were more than 1,600 nationwide, and they continue to grow monthly. Ryan Maloney, the brewer at Mispillion River Brewing Company, said that for just under a $70,000 investment in equipment, a restaurant could convert itself to a brewpub. And that is if they want top-end small-batch brewing equipment. A homebrew setup similar to the one Sam started brewing on for Dogfish Head would cost less than a tenth of that. It is a temptation that restaurants continue to at least take into consideration.

Along with the production of beer on premise comes the temptation to begin trying to sell it off premise. It is a balance that many brewers take into consideration and some eventually let go. As Dogfish Head began expanding, so did Stewart's. In addition to its contract with the Blue Rocks, the brewery was distributing throughout the region. It didn't take Al Stewart long to decide that he didn't want to continue to increase production because that isn't why he got into the brewpub business. He chose the brewpub as much

for the restaurant aspect as for the beer aspect. He likes the idea of serving unique beers, but he also liked the idea of serving camel burgers (Stewart's would eventually gain fame for its game burger specials). What he wanted to do wasn't compatible with being a major beer distributor. It also wasn't compatible with running a catering hall, which he also did for a while.

Just as the breweries were finding the best practices through trial and error, so, too, were the brewpubs. As we've mentioned, one of the things that sets Stewart's apart is that it is located, improbably, in a shopping center. The brewpub was actually the first tenant, which meant that he had to cut the drains for the brewery into the newly poured cement. That was the downside. The upside was that when the adjacent building was unoccupied, Stewart's was able to expand into the banquet business. But it also had been in the cigar bar business.

Stewart's reverted to its roots (operationally anyway) after the beginning of the financial crisis. Stewart's today is part sports bar, part pub, part high-end dining and all brewery. It isn't clear whether he started the convention, but Stewart installed a floor-to-ceiling glass wall between the bar area and the brewhouse. In some respect, this was to remind people that they were inside a working brewery. But more than that, it was taking advantage in showing off the Peter Austin tanks. Forget the steel tanks that you might be used to seeing—the brewhouse at Stewart's is a wood tank and brick-wrapped copper setup that, because it was made in the 1990s, looks more out of time than antique.

Al said that he's pretty happy doing what he's doing; sometimes he or Ric will arrange to do a special release for friends or special events. When he overbrews or needs additional space, he has friends in the restaurant business who are always happy to have some of his beer—Pig and Fish and the Pickled Pig are two of the restaurants most likely to have the rare Stewart's export on tap. He looks at what could be called the new brewpub boom only with a little jealousy—and at Iron Hill with no jealousy at all. That is, the temptation to open one more Stewart's Brewing Company is omnipresent, but the disposition to open more than that is nonexistent.

Beer Tetris

If you're leaving the Delaware Seashore State Park bound for Rehoboth Beach, the town of Dewey barely rises up before it is in your rearview mirror. Taking up what amounts to just a little more than 190 acres of beachfront

property, Dewey is home to just about 350 people year round. During the summer, though, that number is in the thousands, and it is one of the more popular, and more upscale, destinations for food and drink. It also is home to two brewpubs (and probably counting).

Clint Bunting owns the building and is partners with the brewers who own the first one that opened. The Dewey Beer Company was nearly three years in the making. Clint and one of his former lifeguarding colleagues who became his friend, Brandon Smith, had been talking about opening a brewery for a while. Both were enthusiastic drinkers and savvy restaurateurs, but neither had a lot of brewing experience. Another friend of Brandon's, Michael Riley, did.

The plan was to open a production brewery somewhere, but when Bubba's Grill (breakfast anytime) closed with no intention of reopening for the following season, the guys started considering the brewpub model. It didn't take them long to discover that the latter would be both better for them as people and more profitable as a company. On the face of it, there is a pretty significant expense in keeping a restaurant open in a beach town that practically closes for the season in September. But Dewey is not far from Rehoboth, where twenty years earlier, Sam Calagione had faced similar difficulties. Plus, Michael would be running the brewery part time at first; he was a science teacher by profession.

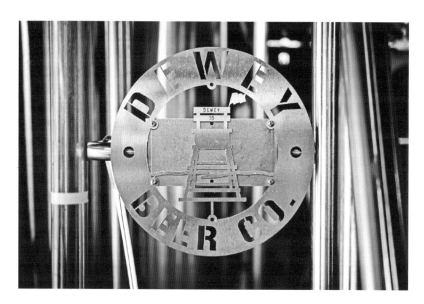

The Dewey Beer Company set up shop in a very small place, but the brewery doesn't plan to grow to do much more production than it currently is doing. Instead, it hopes to become a staple and, if needed, open additional places on the Iron Hill model.

During the two years they were preparing to open, Michael upped his game by working with local brewers and soliciting their help. Jason Weissberg, the head brewer at Assawoman Bay Brewing Company in Ocean City, Maryland, and Dan Webber, one of the brewers at Dogfish Head, gave him advice, guidance and, occasionally, even hops. So while the Dewey Beer Company guys got their business plan together and their recipes in order, Michael continued to practice his brewing technique. He began studying even harder to get a sense of what he would be in for when he was running his own seven-barrel system.

There were people in town who weren't thrilled with the idea, and Clint and the guys had to do more than a little PR work and politicking to get permission to begin brewing on site. Objections to brewing on premise tend to be based out of fear or ignorance, although occasionally they can be based on spite.

When Dogfish Head opened its brewery and distillery in Milton, there was more than a little bit of objection from the townspeople. They were worried about the smell and about the trucks coming in and out at all hours of the night, but most of their fears were pretty easily addressed to their satisfaction. The Milton brewery is now not only a major draw for the town, but people from the adjoining neighborhood also often walk over for the evening and let their kids play on the property.

In the case of the Dewey Brewing Company, there was a little animosity from several members of the public when it was granted permission to brew there. But by the time its first summer in business had come and gone, it had become clear how utterly unobtrusive brewing can be, especially for a brewpub. Strictly speaking, a brewpub is a brewery that sells at least 25 percent of the beer it makes on site. For starters, the Dewey Beer Company sold 100 percent on site.

Although most craft brewers still cannot make enough beer to satisfy demand, getting a consistent number of tap handles (places that serve your beer) can be difficult. Small breweries, even those with sales staff working the streets, can have trouble competing. In some cases, new breweries can't keep up with demand and lose their spots; in other cases, demand has nothing to do with it and they are at the mercy of the bars and restaurants, which like to have a lot of different beers on tap and keep them rotating through.

Opening in a resort during the summertime meant that none of those decisions was necessary. As a restaurant one block from the beach, Dewey Beer Company wasn't making enough beer to have any extra. Michael spent his summer vacation double batching to keep up with the demand over the bar. The restaurant, which cooked with the beer in mind as well as with the beer as an ingredient, became pretty popular in its own right. The front opened completely so there was always a nice breeze throughout the season.

The brewery's tanks fit into what possibly had been a half-garage with a little more than a foot clearance above and three or so feet walking space between the tanks and the restaurant wall. The grain and the millhouse were pushed to the back into the corner. The Dewey Beer Company had zero room to grow before it opened the doors, but that wasn't a great concern for the guys. They are young and like working and are making a living at it already. During the winters, they will have the opportunity to brew enough beer to get ahead of themselves a little bit and also to share with some of their neighboring restaurants if those restaurants want any.

Elder Statesman

The Dewey Beer Company hasn't announced plans to grow, but if it does it likely will be on the Iron Hill model. Its food and culture has turned out to be conducive to export, but it is in no rush to see if the market is ready for another exportable brewpub. Toward the end of 2015, Clint and the rest of the guys had the opportunity to support Gary's Beach Grill, another Dewey restaurant that specialized in craft beers. After twenty-five years in business as a craft beer oasis, Gary Cannon wanted to begin making just enough beer to have a house beer on tap next to the dozens of craft beers the restaurant has been carrying.

After having the "old" brewpub in town speaking in favor of the business expansion, Gary was given permission to start brewing. This is likely the future of brewpubs. People will come to expect a house beer at some of the better restaurants. No one would have referred to the beers in nineteenth-century taverns as "house ales." They probably would just have referred to them as beers, but that was a radically different era.

Beer always has been good, but it never has been much of a recognized flavor center until the second half of the twentieth century. With the rise of craft beer and its diversification, we are improving our palates and enriching our culture. The exciting part of the rise of craft beer, though, doesn't have as much to do with taste and choice as it has to do with community. People in Delaware and up and down the Delmarva Peninsula are never too far from a place where fresh beer is made. We gravitate to these places—yes, because the beer is good, but also because the people are too. Craft beer has given Delawareans one more excellent reason to come together in community centers and celebrate the fact that some of the finest beers in the world also are some of the finest beers in their towns.

Selected Bibliography

Beer Institute. www.beerinstitute.org.

Flock, Elizabeth. "Hopslam: How Big Beer Is Trying to Stop a Craft Beer Revolution." *U.S. News and World Report*, February 8, 2013.

Medkeff, John, Jr. *Brewing in Delaware*. Charleston, SC: Arcadia Publishing, 2015.

Okrent, Daniel. *Last Call: The Rise and Fall of Prohibition*. New York: Scribner, 2010.

Sharff, John Thomas. *History of Delaware, 1609–1888*. N.p., n.d.

INDEX

INDEX

About the Author

Tony Russo got into journalism after college because he'd heard the saying, "Journalism is history's first draft," and as a philosophy student, it seemed preferable to learning to make lattes. He has worked as a journalist since 2004, writing and editing for daily and weekly newspapers and magazines, and most recently as editor of OceanCity.com. Tony has written about beer almost since the start of the craft beer revolution in the region. He cohosts a popular weekly podcast, *Beer with Strangers*, and runs the ShoreCraftBeer.com craft beer lifestyle website. He lives in Delmar, Maryland, with his wife, four daughters, two dogs and surprisingly no ideas for a sitcom.

ABOUT THE PHOTOGRAPHER

KELLY RUSSO takes pictures. Make sure to have them screwed to your wall if she ever comes to visit. She is one Kelly tall, and while portrait work is her first love, she enjoys capturing life's moments as they happen. Her work can be found at www.KellyRussoPhotography.com.